REMEMBERING

ZIONSVILLE

REMEMBERING

ZIONSVILLE

JOAN PRAED LYONS

Charleston London

THE
History
PRESS

Published by The History Press
Charleston, SC 29403
www.historypress.net

First published 2009
Second printing 2012

Manufactured in the United States

ISBN 978.1.59629.667.1

Library of Congress Cataloging-in-Publication Data

Lyons, Joan Praed.
Remembering Zionsville / Joan Lyons.
p. cm.
ISBN 978-1-59629-667-1
1. Zionsville (Ind.)--History. 2. Zionsville (Ind.)--Social life and customs. 3. Community
life--Indiana--Zionsville--History. 4. Zionsville (Ind.)--Biography. 5. Oral history--
Indiana--Zionsville. I. Title.
F534.Z46L97 2009
977.2'54--dc22
2009019601

CONTENTS

ACKNOWLEDGEMENTS

This book would not exist without the individuals and organizations that were willing to share personal knowledge or facilities that provided the history recorded on these pages. Since one is no more important than another in the collective whole, I'll start with the person who first ignited my interest in Zionsville history.

Sandra Brock Cline was editor and publisher of the *Zionsville Times Sentinel* in 1986, when Indiana governor Robert Orr unveiled his plan to encourage the smaller communities in the state to: 1) find a way to celebrate the history of the town; 2) develop a project that would improve their community; and 3) hold a celebration of those accomplishments in 1988. He called his plan "Hoosier Celebration '88."

At that time, I had moved up through the ranks at the newspaper from accident reports to feature stories. Cline asked me if I would like to join her in a project that would result in an oral history of the community, for which we would need to involve as many people as possible. I agreed, but realized that, as an eight-year resident of the town, I would be expecting lifelong residents to entrust me with their stories and photos. I asked to introduce my weekly "Past Times" column to make their acquaintance and build their trust. *Zionsville: The First One Hundred Years: An Oral History of the Community of Zionsville, Indiana, from 1852 to 1952* was the result. "Past Times" has extended far beyond its intended purpose, having recently celebrated twenty-three years. And now, thanks to The History Press, "Past Times" interviews will inform a wider audience.

ACKNOWLEDGEMENTS

Over the years I've learned to depend on the Patrick Henry Sullivan Museum, a part of the Sullivan/Munce Cultural Center, and its repository of local history to verify information and to add the detailed facts few people store in their memory banks. Marianne Doyle was particularly helpful in introducing me to the numerous means available to satisfy my needs. Most of the photographs that enhance the stories in this book came from museum archives.

Among the treasure-trove of information at the museum are reels of microfilm of the local newspaper from shortly after it was published for the first time in 1860 by A.G. Abbott. So, a huge "thank-you" to Mr. Abbott and to the many editors who have succeeded him, especially Greta Sanderson, current executive editor, who opened another door for me by inviting me to write five two-decade sections during the millennial year. Those sections, joined by another covering the period between Zionsville's founding in 1852 and the end of the nineteenth century, became another book published on grants, in time for the town's sesquicentennial: *Rails to Trails: 150 Years of Zionsville, Indiana, History*.

I am especially grateful to the Hussey-Mayfield Memorial Public Library for installing my columns on its website, where I was "discovered" by The History Press.

I also deeply appreciate the advice and encouragement I have received from Stephen Anspaugh, retired teacher and leader of our writers' group that meets monthly at the library.

THE RAILROAD: MID-NINETEENTH-CENTURY NUCLEUS OF A THRIVING COMMUNITY

EARLY SETTLERS WERE DRAWN TO THE RAILROAD AS IF TO A MAGNET

Just as transportation holds the key to development today, so it did in the early to mid-nineteenth century, when pioneers began to settle in this part of Indiana. As stalwart men and women sought homesteads on the frontier, they chose to settle first in those areas that were easier to reach.

Of course, there were those men who went on ahead of their families, literally by slashing their way through the heavy forestation, to prepare a track for the wagons that would follow. This was a lengthy task, fraught with all kinds of hardships and danger.

By 1827, work on the National Road, a public road that would cross the state from Richmond on the east to Terre Haute on the west, was in progress, and by 1830 a north–south public road from Madison on the Ohio River to Lake Michigan, known as the Michigan Road, was begun. These roads made it much easier for settlers to make the journey from their homes in eastern or southern states to land they sought as homesteads.

The roads also opened the area to those traveling by stagecoach, and the frontier communities to goods that were transported by stage from such faraway cities as Cincinnati. A new industry was born, as the route followed by the stagecoaches needed regularly spaced facilities where the driver could stop to feed his passengers and horses, or to bed both at night.

Eagle Village became a stagecoach stop soon after the Michigan Road was completed to that point. As a result, the community flourished, with

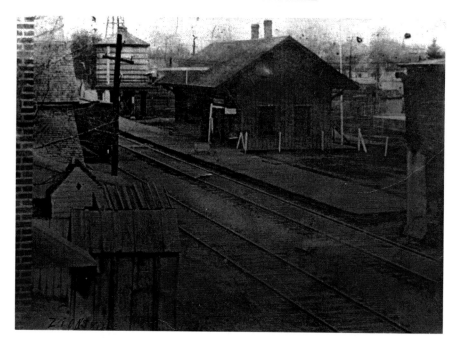

The first depot serving the newly platted town of Zionsville was this rough structure essential to the Indianapolis, Cincinnati & Lafayette Railroad that was the nucleus of the new town. *Courtesy of the Sullivan Museum.*

taverns, stores, tradesmen, churches and a school, until…the railroad was laid about one mile west of the village.

William Zion, a businessman in Lebanon, the growing town to the north, was also a member of the board of directors of the Indianapolis, Cincinnati & Lafayette Railroad. He convinced Elijah and Mary "Polly" Cross that a town could and should be laid out on their Eagle Township land, through which the railroad would pass. Zion and Cross became partners as proprietors of the proposed town and drew a rough plan of their ideas.

James Mullikin, Boone County surveyor at the time, surveyed the site and drew up the original plat consisting of six full blocks, three half-blocks and five quarter-blocks, on approximately twenty-eight acres. Cross and Zion filed the report and chart he prepared in the Boone County recorder's office on January 26, 1852.

According to the late Boone County historian Ralph Stark, writing in *"Birth Certificates" of Boone County*, "The lots were each 60 by 120 feet in size. The streets were 60 feet wide with the exception of Water Street, which was 30 feet in width. The width of the railroad right-of-way was given as 50 feet."

The Railroad

Cross wanted to name the town Marysville in honor of his wife, but she declined. He then chose to immortalize his partner's name by christening the town Zion's Village, and then changing it to Zionsville. Zion himself never lived in the town, nor did he own land there.

A Cut-off Mail Route and a Moving Depot

Four times a day, Schemer Fultz hitched his favorite driving horse to his small spring wagon for the trip out to the new railroad west of town. Just before the 6:00 a.m., noon, 2:00 p.m. and 6:00 p.m. trains were scheduled to pass through Zionsville, he made the trip from the post office on Main Street out Pine Street to Laurel, the street that angled straight toward the siding where a railroad car was set up as a makeshift office.

With him, he would take the mailbag with outgoing mail, which he would carefully hang from the hook suspended at just the right spot for the mail

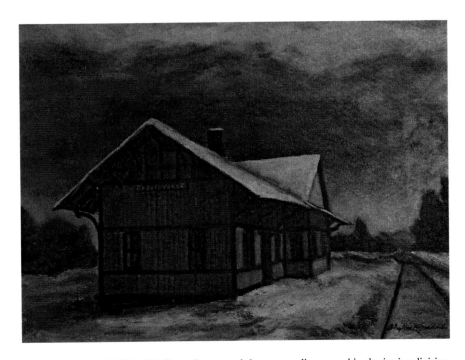

This oil painting of "The Old Depot" captured the outstanding award in the junior division at the Indiana Art League Foundation exhibition at Indianapolis in December 1964 for Zionsville artist Phyllis Kinnard. *Courtesy of the artist.*

clerk on the passing train to grab it with a hook. Schemer would wait in the office, sometimes a very long while, until the train picked up the mailbag and threw off a sack of incoming mail for him to deliver to the post office.

In the winter, it was still dark at six o'clock in the morning and dark again before six o'clock in the evening, so he would carry along a lighted lantern. There were no buildings near the Big Four track (Swiggett Lumber would come later) and the few streetlights in town were in a more populous area.

Schemer's route was called a cut-off mail route, and as a drayman, he bid on it. Created when the track on First Street was abandoned for the new track, the route was only one of the jobs that were his livelihood. Like Ben Davidson, his competitor, he hauled anything that needed to be hauled in Zionsville and the surrounding countryside.

Originally a farmer, Schemer, whose given name was Omer D., worked on his father's farm and for Martin Clampitt, a neighboring farmer, before becoming a drayman. He and his wife, Pearl Findley Fultz, moved their family to Zionsville in 1911. Living first at Fifth and Ash, and then on Maple, they moved to the small house on Elm when their daughter Margaret (Coval)

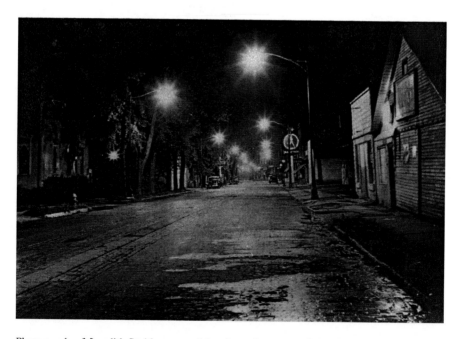

Photographer Meredith Smith captured the glow of new streetlights, looking south on Main Street in 1939. *Courtesy of Meredith Smith.*

was a small child. When she was a teenager, they moved just up the street to the northwest corner of Cedar and Elm.

Margaret well remembers the blacksmith shop that was located on the back of the lot behind their Elm Street house. She, and other neighborhood children, enjoyed peering in the windows to watch the blacksmiths at work. She also recalls that, in the early 1920s, the depot was moved from its original location at Cedar and First to a spot beside the new tracks.

Myron Crane reconstructs the move with a winch used to move the building. He offers high praise for the movers, who were experts at moving a structure without even cracking the plaster, and he credits their success to the slow, steady progress that the use of a winch would afford.

After the foundation was laid at the new site, Frank Gregory and his crew jacked up the depot and two or more huge wooden beams were slid underneath it. The two beams placed underneath the structure would have been fastened together with two by sixes or two by eights bolted at the front and back and braced so that they couldn't twist. Then a winch would be placed three to four hundred feet away from the structure, with cable attaching it to the beams that extended about a foot at the front and back of the structure.

A horse hitched to a singletree, or a team of horses hitched to a doubletree, would be connected to the winch by an arm. The horses would walk in circles around the winch, winding up the cable and steadily moving the structure down the road. When the cable had been wound, the winch would be reset and the process repeated.

Blocks on top of the beams at the front and back would keep the building firmly positioned, and a brake would facilitate stopping and help the winch control the structure at the end of Laurel, where there was a downward slope.

Paul Way remembers that some buildings were moved successfully by a different method. After beams were positioned under the structure, a couple of dozen wooden rollers, probably oak, about eight inches in diameter, were placed under each beam.

A team of horses, harnessed in doubletree, was fastened by a log chain to each beam. As the horses pulled, the five- to six-foot rollers rolled along underneath the beam, coming out in back. Crew members would then pick up the rollers as they came out, carry them around front and reinsert them. If the rollers swerved from course, the men would straighten them with a crowbar.

The depot probably followed the same route Omer took each day, traveling down First to Pine and then west to Laurel and the train tracks. Although there is a gradual rise on Pine and Laurel, there is less incline than on Oak or Cedar, Paul said.

If the roadbed were soft in any place, planks would have been laid down ahead of the rollers to firm their path.

EARLY TOWNSFOLK
HAD RURAL ROOTS

AND THEN THE BARN SAID...

Everyone knows that barns can't talk…but just suppose they could. What great stories some of them could tell! For instance, the 116-year-old barn on the Dwight and Dorothea Renner property on Zionsville Road recently got a new lease on life in a beautiful new setting.

An interview with it might go like this:

Sure, I'm feeling pleased with myself these days. I haven't looked this good since I was in my prime—soon after David Ingmire pounded the last peg into my solid oak beams in 1893. Now there was a craftsman! I'm testimony to that. My joints are still so tight you can't get your fingernail in them.

Red Renner was David's grandson, and he loved to tell his friends about his grandfather when they stopped by to see me in all my glory. Seems the old man, David Brough Ingmire, was a Civil War vet who took a bride, Ephphiah Smith (called Effie), back home in Ohio and moved to Boone County just northeast of the old Clarkston that was located then where Willow Road crosses Michigan Road. They lived just across the road from the Liebhardt Woolen Mill for several years, and then moved on up the road to the other side of the bridge and settled near Little Eagle. That's where Red's mother, Sylvia Opal, was born, the youngest of six children.

Her father was a skilled carpenter, having apprenticed for seven years as a lad, although his apprenticeship was interrupted by the Civil War. He

This barn was built 116 years ago by Civil War veteran David Brough Ingmire, who carried a musket ball in his right elbow at that time. *Courtesy of William Dwight Renner.*

was a member of the Sixty-third Ohio Volunteer Infantry and was shot on his seventeenth birthday during the Battle of Atlanta. He still had that musket ball in his right elbow when he was building me, and he carried it to the grave with him. Red said he took part in Sherman's March to the Sea with his right elbow in a sling, serving the general as a forage sergeant.

He'd built a lot of barns up there around Little Eagle by the time the Swaims hired him to build me. I heard tell he got one dollar a day and found for the job, and his helper got a quarter a day and found. For all you youngsters out there, found means that the Swaims fed him and his horse a noon meal. It better have been a big one, since workdays back then ran from sunup to sundown, and he did all his work by hand. The closest thing he had to a machine was the boring tool that ran on muscle power.

I turned out to be just what the Swaims needed, with stalls for four to six horses and a grain bin on one side, a drive-through for a wagon in the center and stalls for six cows on the other side. Above was my hayloft.

Effie Ingmire died when Sylvia was five, and by 1908 only David and his youngest daughter, a teenager, were left on the farm. They moved to the northern outskirts of Indianapolis, near Thirtieth and College, and Sylvia finished high school at Shortridge. Her dad built houses in their

neighborhood and she kept his books and acted as a buyer for him while she went to business college.

She met and married William Dwight Renner from Columbus, and they had a son, William Dwight Renner Jr. When the youngster (Red) was five, the family moved to Boone County, settling south of Zionsville, where they bought part of the Harvey farm. About fifty-five to sixty years ago, they bought the land where I originally stood on the Swaim property. Since they already had a barn closer to the house, I was relegated to farm equipment storage. As the years went by, I began to show my age, a condition that didn't go unnoticed by Red, who had inherited his parents' farm.

He and his wife, Dorothea, decided to protect me from the elements and give me a good life where they could show off my mortises and tenons that David had anchored with green oak pegs so long ago.

Their solution was to move me across the field, nearer their home, and give me a new roof, skylights and windows, a chimney and barn red aluminum siding. Inside I still look pretty much the same as when David finished me, but of course, I'm much cleaner in my new role than I was as home to all those cows and horses.

Red found an old wood-burning stove that he restored to keep me cozy in the wintertime, and my corncrib is equipped with modern plumbing. He also wired me for electricity.

My loft became Dorothea's studio, where she painted surrounded by a collection of antique tools, including her grandfather's rake, an unusual ten-pronged pitchfork, an antique grinding wheel, a grain cradle and my original hay fork. Her grandmother's hand-carved ash rolling pin and other wooden kitchen tools and baskets line the walls and sit atop my beams.

I stand beside a lake Red created by draining fifteen acres of farmland. I'm now the center of attention when friends are treated to cookouts and rides on the pontoon boat that is tied up along the shore.

What a way to grow old!

BERRYS AND DUZANS WERE AMONG EARLY SETTLERS

On February 11, 1861, Henry Clay Berry saddled his horse and rode from his home on 86th Street, near where the superhighway now rises above the surrounding countryside, to Zionsville to witness a very special event. The train bearing Abraham Lincoln, on his way from his home in Springfield,

Illinois, to Washington, D.C., for his inauguration, was scheduled to stop in Zionsville, and Henry hoped to see the president and maybe even hear him speak.

It was late afternoon when the train finally rolled to a stop in front of the depot. But those who had gathered along with Henry were not disappointed. The president appeared on the flag-draped rear platform and spoke briefly to the assembled crowd. Among those who heard Lincoln's words, according to Zionsville historian the late Adron Sluder, were E.S. Cropper, John M. Mills, Minerva Alford Carter, Cannie Alford Mills and Trougott Swaim.

The train was a vital communication link for the people in those days, and was the principal reason for the growth of many towns, Zionsville included. Supplies came in by train, and farmers from the surrounding countryside brought in their products to be shipped elsewhere. Travel, too, was much more direct and faster by rail than it could possibly be by horse-drawn vehicles over the dirt roads, some impassable at certain times of year because of mud.

Henry's wife, the former Mary Eliza Duzan, had used the train to travel to her job as a schoolteacher before their marriage. She and another teacher would board the "milk train" (the first train in the morning, used primarily to ship milk) and ride to a point near their schools. Because it was not yet daybreak when they disembarked, they would sit on a fence and wait until daylight, when each would walk to her respective school, in opposite directions. Of course, this was not a daily occurrence. Mary, who taught near Whitestown, boarded on weekdays with the Gochenours on Lafayette Road, returning to her home each Friday after school to spend the weekend.

She was the daughter of John and Catherine Cox Duzan. Her father owned a gristmill on Eagle Creek west of Zionsville, where they had settled around 1834.

In later years, Mary shared her memories of those early days with her grandchildren, and one in particular, Mary Beatrice Beelar Fink, listened well and passed them along.

Diphtheria and scarlet fever both reached epidemic proportions during Mary's days as a teacher. School was closed, and since her brother, George Nelson Duzan, was a doctor, she was expected to help care for the victims. Dr. Duzan, unlike many of his contemporaries, who trained at the side of an experienced doctor, attended medical school in Pennsylvania. He practiced medicine in Zionsville until he became a surgeon during the Civil War. When the war ended, he moved his practice to Indianapolis, where he taught in medical school.

Early Townsfolk Had Rural Roots

Mary often told her granddaughter, Beatrice, "If I hadn't gotten married, I would have liked to be a doctor." It was a profession she obviously respected far above her own, since she had told her daughters, "I would rather my daughters would take in washings than teach school" because it was such hard work in those days.

After her husband's death, Mary moved to Zionsville. "Lots of people came to Zionsville to retire," Beatrice says. "Grandma moved into part of Mrs. Vandover's house, where she lived next door to Adron Sluder (school principal and local historian) and helped provide him with some of the information he was gathering about the community."

Mary's uncle was Philander Anderson, who built the Octagon House, and it was her brother, George, who figured out how much plaster it would take for each of the rooms that was shaped "like a slice of pie with a bite out of it," she said.

CHINA LOHMAN BOUGHT PELTS, SOLD FURS FROM HOME ON WALNUT STREET

Houses, like people, each have stories to tell. Each is different. Unique—special in its own way. One such story of a house and the man who lived in it comes to mind because the house was once on the Village Tour of Homes. Located at 150 West Walnut, the Danner Home, as it was identified to tour-goers, was once the home of China (pronounced "Chinee") Lohman, one of Zionsville's more colorful citizens.

His mother, Golena, moved there with her sons sometime after the death of her husband, Joe, in 1936, and China, who never married, continued to live in the house after her death in the late '50s. It was there that he conducted his fur business, buying animals or pelts from local trappers and selling furs to area furriers who would come there to select dried furs from the piles that were stored in the room at the southwest corner of the house.

But let's start China Lohman's story nearer the beginning. Like most of the boys who grew up soon after the turn of the century, he was known around town by a nickname. Although his given name was Raymond, everyone called him China, and the nickname stuck with him all his life. They say he picked it up when, as a small boy, he wore a stocking cap that was so tight it made his eyes slant.

Veteran "Past Times" readers will recall that, as a child, he and three friends, Hot Times, Brom Bones and Dick, used to play cops and robbers in the old Water (Elm) Street jail when it was not being used to house transients. As he grew older, he developed a taste for practical jokes. Some of those jokes live on in the memory of those who knew him. Earl Russell recalled that Zionsville teacher and historian Adron Sluder was the butt of at least two.

China's Walnut Street home was just two doors east of Sluder's house, and Adron used to have a small vegetable garden just back of the Lohman place. One evening, China went out into Sluder's garden plot and buried tin cans in rows about every six feet. The next day, as the portly gentleman pushed his plow through the earth, China and his companion in mischief, Earl, could hear the dignified educator "Oooff" each time the plow struck a can, causing him to bump against the handle.

In order to pull off another joke on Sluder, Lohman suffered somewhat himself. The two planned to go somewhere in his Ford roadster with side curtains, so China went out first to start the car and, incidentally, turn on the heater. It was a summer day, and as the car moved along the road, Adron kept mopping his brow, finally commenting, "It's sure warm today." Only then did China break down in laughter and turn off the heat.

Some of his jokes brought retaliation in kind. Howard Bragg and China liked to play practical jokes on each other. Howard lived at the southeast corner of what is now State Road 334 and Sixth Street.

One day China took a basketful of trash and set it in front of Bragg's house with a sign on it that said "City Dump." Bragg was amused, but he also got even. He called the sheriff, who pursued the joker to Swiggett Lumber Company, where he worked as a handyman, read him his rights and marched him off in handcuffs. They were partway to Lebanon before the sheriff allowed himself to be talked out of the arrest.

One time China's sense of humor cost him—ten dollars. Paul "Dick" Way, one of China's childhood friends, recalls what happened when one of China's jokes offended the victim. There was a leak in the water main near the old depot. Digging to make the repair left a mound of dirt that resembled a grave. China seized the opportunity and planted a sign in the mound saying, "Here lies the body of _____ (the name of a local man who couldn't read)." The man found out what the sign said and didn't take it kindly. He sued and won ten dollars.

Early Townsfolk Had Rural Roots

Though his jokes did occasionally go a bit too far, China was one of those men who liked everybody and everybody liked him. He played the banjo, and his friends would congregate on the Lohman front porch to sing along. But his life wasn't all practical jokes and songs. Besides working at Swiggett and at other odd jobs around the community, he worked for the railroad at one time. His father had been a section boss. He also developed two businesses of his own. One was the fur business that he conducted from his home and the other was a landscape business—Lohman Nursery—that he developed on four acres he owned on Kissel Road. The fur business and landscaping complemented each other very well, for both were seasonal—one in winter, the other in summer.

When furs were selling high, China worried that he might be robbed, so he would take the furs into the cellar each night, using a trapdoor underneath the dining table.

In 1915, raccoon skins were bringing five dollars each; muskrat and possum, twenty-five cents.

Berries and Cream, the Hard Way

As soon as she was old enough, Sparkle Moore (Furnas) worked alongside her parents on the farm. She remembered clearly the protection required when picking wild raspberries or blackberries. Of course, young ladies didn't wear jeans in those days, but their underwear was long, much like the thermal underwear of today. Over this they pulled up long, black cotton stockings. They tied mosquito netting over their bonnets and wore old stockings over the long sleeves of their dresses, with just a couple of holes cut out to permit finger and thumb to emerge for plucking the berries. This gear kept out most of the huge mosquitoes that infested the area, as well as the poison ivy that was prevalent, and protected the pickers from brambles.

Not only did Sparkle pick berries for her mother to use in making pie, cobbler, jam, jelly and to can, but she also earned money to save for her future college expenses by selling some of the berries she picked. "People would come to our house to buy gallons of them," she recalls. "We also took some to sell to housewives in town. I believe that we got about fifty cents per gallon for them."

Another of Sparkle's chores was to go out into the pasture and drive six to eight milk cows the Moores owned into the barn at milking time. She

Sparkle Moore Furnas commissioned this drawing of the Moore homestead from memory, since she had no photo of her childhood home. *Courtesy of Sparkle Moore Furnas.*

learned to milk cows when she was very young, and continued to do so until she went to college. Although most of the cows were Jerseys, her father bought an occasional Guernsey.

"High Stepper" was the name given to one particular Guernsey because she was always rather frisky and would often kick over an almost full bucket of milk. "I remember one time when she kicked and planted her foot firmly down in the pail of milk and pressed the bottom right out of the pail," Sparkle recalled. "After that, we had to put a hobble on her hind legs before starting to milk her."

A cream separator in the kitchen of the log cabin was used to separate the cream from the milk. First the milk was poured into a large container at the top; then, by turning a hand crank, the milk was forced down through a series of disks and screens. Centrifugal force sent the heavier skimmed milk to the outside and the lighter cream would rise in the center.

The skimmed milk was fed to the hogs and the chickens, and her mother used some for cooking and for making smearcase (cottage cheese). Nothing was wasted, so the whey that was strained off the smearcase was fed to the hogs. Mrs. Moore also made a soft yellow cheese that her family enjoyed.

Early Townsfolk Had Rural Roots

Cream was used on cereals, fruit and for cooking, and sour cream went into devil's food cakes, pancakes and biscuits. The balance of the sweet milk went into earthenware jars that were kept cool in the milk house, where they were set in cold running water. About once a week, there was enough cream to churn into butter.

Any butter the family didn't use was sold to the huckster who came by periodically to buy butter, eggs and chickens. He had a scale in his wagon and would weigh the chickens and the butter and pay the farm wife in trade with sugar, salt or the few other staples she might need.

As soon as a creamery was established in Zionsville, William Moore took five-gallon cans of cream there to sell instead of turning it into butter. Only enough butter was made to supply the family needs. Years later, the creamery made daily morning pickups of cans of fresh milk, which they would then pasteurize and sell in bulk or in bottles.

Harvey Sisters Recall Childhood in Zionsville before Turn of the Century

It is not very often that one has the opportunity to talk with two ladies who have seen so many years of Zionsville firsthand. But that is just what happened when I called to confirm my scheduled interview with ninety-one-year-old Euva Harvey. Miss Harvey suggested that I might like to talk also with her one-hundred-year-old sister, Nola Huckleberry, who was in a Lebanon nursing home. Unfortunately, their younger sister, Edna Lovett, was ill that day and unable to join us, as was their brother, Dr. Ralph Harvey, who had been hospitalized with a broken hip. When you are preparing to write a book on Zionsville history, it is a dream come true to find two ladies whose memories of life in the community extend back for the better part of a century.

Nola, who turned one hundred on February 25, 1986, came to Zionsville when she was a second grader in the yellow brick schoolhouse that stood between Fifth and Sixth Streets where the varsity gym stood at the time of the interview. It is now the site of the Hussey-Mayfield Memorial Public Library. Her teacher was Miss Emma Smith, called "Miss Emma" by her pupils, who shared double desks in a classroom that served both first and second grades.

Each pupil had a slate as well as a writing tablet, and the textbooks belonged to the students, who passed them along to younger brothers and sisters. This

This yellow brick schoolhouse, known as the Academy, was the second schoolhouse to serve the community. It stood on Walnut Hill, in the space now occupied by the library. *Courtesy of the Sullivan Museum.*

was a considerable savings, especially when there were ten children in the family, as there were in the home of Stephen and Laura Harvey, parents of Nola and Euva.

Each desk held an inkwell, and the second graders learned how to write with ink. Using a pen point, or nib, made of split metal that was pushed

into a wooden holder, the children learned penmanship that was beautiful to behold.

School days commenced at 8:30 a.m. with an opening ceremony that began with prayer and included the reading of chapters of the Bible and singing church songs. During the school day, which lasted until 4:00 p.m., everyone in the classroom was either reciting or studying, except for an hour-long lunch period and two recesses. Nola recalls that the boys and girls had

separate playgrounds for recess, but play equipment consisted of a baseball for the boys and nothing for the girls, leaving them to play such games as Annie Over and Black Man's Bluff, later called Blind Man's Bluff.

In a family the size of the Harveys, there was little leisure time for anyone, and Nola immediately was put to work after school peeling potatoes or some other task in preparation for dinner. Boys and girls did not share chores, but each sex had particular chores that were regularly assigned.

There was always some time on weekends, however, for the children to play with their friends. One particular Sunday in 1895, January 27, to be specific, Nola was sliding down the big hill at the school yard when "this boy who thought he knew everything" taunted her with, "Ha! Ha! You've got a new baby at your house."

"I said, 'We have not!'" Nola recalls, "but he insisted, saying he had seen the doctor go into our house with his black bag."

Later, when she walked in the door of her home on the southeast corner of Cedar and Fifth Streets, she found that her antagonist had been right. They did indeed have a new baby, a little girl weighing just a little over five pounds.

The baby girl was Euva, who has since asked her sister if her denial had meant she didn't want her. "No," Nola assures her, "I just didn't want *him* to tell me."

It makes Euva sad to hear that from then on Nola often had to substitute watching the other children for taking part in their games because she was carrying her baby sister on her hip. But Nola didn't feel sorry for herself. On the contrary, "I felt very grown up that mother was trusting me with the baby. Ocie [the eldest Harvey daughter] was in high school and that wouldn't have been very dignified for a high school girl to take care of a baby."

BEFORE SOCIAL SECURITY, GOD MADE BROTHERS

Long before Social Security or insurance policies provided a regular income for widows, God made brothers. And it was to them, the male relatives, that widows often turned in the 1800s for food, shelter and clothing for themselves and their children.

Mary Jane Essex Lutz, as the only girl in the family who lived to adulthood, was especially blessed with six brothers and two half brothers. When her husband, W.F. Lutz, died of a disease contracted while he served his country

This bill of sale sent to his sister by Joshua Essex provides a fascinating look at what the adequately equipped kitchen required in 1886. *Courtesy of Anna Essex Crane.*

in the Civil War, she was left with a young son and daughter, and only the small pension provided for veterans' families.

Each brother did what he could to help. Sam Essex, who lived in Zionsville, built his sister a house next door to his own on the main street. Brother William, a farmer, brought her eggs and, when he butchered, meat. Because she was too proud to let her neighbors see her receiving charity, even from relatives, she insisted that he leave his buggy in the alley and come in the back way when he was bringing food.

Brother Joshua was a partner in the firm of Essex and Conron in Danville, Illinois, which sold hardware, stoves and tinware. His contribution to his sister was to outfit her new kitchen with a stove and utensils at a reduced rate. The bill of sale from this transaction provides a fascinating look at what the adequately equipped kitchen required in 1886. Since a number of the items on the bill that we have reproduced are not ones we see in kitchens today, we asked Anna Essex Crane, William's daughter, to tell us about them.

The wood-burning cookstove, made of cast iron, had a reservoir so that hot water would always be available. The reservoir was a tank that would hold five to ten gallons, and had a hinged lid for easy dipping. It was located on one side of the oven, with the firebox on the other side.

A lid lifter had a long handle with a hook on the end for lifting hot stove lids. An oven scraper, with a handle about twenty-seven inches long, had a flat blade on the end that measured about three inches long and an inch and a quarter wide. It was used to scrape ashes and soot from underneath the oven so that air could get to the fire.

An iron heater was a round piece of iron with a rim that was set atop the cooking surface. When a pot was set on the heater, the food wouldn't stick as readily as it would when placed directly on the stove.

The pudding pans were probably about the size of our custard cups. An "elbo," or elbow, was a bent piece of stovepipe, and the gasoline can was probably intended for coal oil storage. Coal oil was used for lamps and to start the fire in the cookstove.

Carpet "tax," or tacks, were used to fasten carpet down all the way around the room. In those days, someone with a loom would weave a long, yard-wide strip of carpet for the housewife, who would cut it in strips the length of the room. She would whip the strips together with needle and thread, turn the ends under and fasten the carpet to the floor with carpet tacks. Sometimes she would place newspapers underneath the carpet as a pad and as insulation, or if she lived in the country, she might use fresh straw to make

it soft and easy to walk on. The straw had to be replaced every year, so at that time she would hang the carpet outside on the clothesline and beat it with a carpet beater to get as much dust out as possible.

Wardrobe hooks were used to hang clothes on and were placed either on the walls of a room or in a piece of furniture called a wardrobe, which was used for the storage of clothes in the days before closets were prevalent.

The bell pull would be a chain, a piece of leather or a rope on which a visitor would pull to ring the doorbell. The patent egg beater was the crank style we still use today.

What kind of meals did the housewife prepare for her family in days gone by? For research on the subject, we turned to Anna's husband, Myron Crane, and his friends, who concluded that a day's menu might have looked something like this:

Breakfast (depending on the type of work planned for the day)—sausage or ham and eggs, yeast or soda biscuits with gravy and applesauce. Or the main item might be fried mush or pancakes and syrup. Sometimes bread, toasted on the coals or in a skillet, was served instead of biscuits.

Dinner (the largest meal of the day was served at noon)—fried chicken, mashed potatoes and gravy, applesauce, green or dried beans, ham or sausage and pie (cherry, mince, apple or custard).

Supper—milk mush (a variation of fried mush, served in a bowl with butter and milk) or fried potatoes and leftover chicken from dinner, leftover pie.

Beef was a real treat, enjoyed infrequently because it had to be used fresh from the butcher shop since preservation was so difficult.

In the spring, greens—mustard, slender-leaf dock, dandelion or pepper grass—would appear at meals. Sassafras tea to thin the blood was traditional.

ZIONSVILLE WAS NEVER A ONE-HORSE TOWN

DORIS DAVIDSON WAS THE DRAYMAN'S DAUGHTER

Each time the train pulled up to the depot in Zionsville around the turn of the century with freight for local merchants, Ben Davidson and his dray would be on hand to haul the merchandise to the stores. Either Molly or Maude would be between the shafts to provide the required horsepower, and if the load expected was large—say a carload of lumber—both horses would be hitched to a larger wagon.

Ben had the only dray in town, recalls his daughter, Doris Davidson Russell. She remembers that the dray was a low, sturdy wagon with a high seat across the front and short posts around the sides to hold the merchandise. If solid sides were needed for a particular cargo, boards would be slipped into slots in the posts, usually two end-to-end per side and one across the back.

When the railroad was moved to the west side of the village, the depot was moved also, to a spot near the Swiggett Lumber Company.

Doris spent the first three years of her life in the family home in Hurst Woods, where Raintree Place is today. Ben and Love Reveal Davidson then moved their family to a house on Second Street, where they lived for several years. In the early 1920s, the family moved to a larger property that occupied the entire block bounded by Hawthorne, Sycamore, Fourth and Fifth Streets. There was a barn on the property, so Ben no longer needed to board Molly and Maude, and the family could have a cow, chickens and pigs, and raise some corn.

With four brothers and a sister, Doris, the older daughter, never lacked something to do. She helped care for the children ("There was always a little one") and helped with the housework.

The Davidsons had a carriage with two seats, and it was a family custom to take a ride in the country on Sunday afternoons, occasionally stopping to visit relatives along the way.

Doris and her brothers and sisters walked to school in Zionsville, but she loved to visit her cousin, Halcy Davidson (Shaw), whose father drove a school hack pulled by a team of horses. Sometimes she was allowed to ride along on the back, and she recalls the wood-burning stove at the front that provided some warmth for the young passengers.

In 1927, Doris married Hearn Russell, who was in the plumbing business with his father. Charles Russell and Son had a plumbing shop at the northwest corner of Main and Hawthorne Streets where they sold furnaces, hot water heaters and bathroom fixtures from 1928 until 1959. Before that, the shop was located across from the old church building that houses artist Nancy Noel's *Sanctuary*. Doris helped in the shop when she was needed.

She and Hearn and their daughter Nancy (McCorckle) lived between Nana's Village House Flowers & Gifts and Old National Bank. There they first installed a bathroom in 1930, cutting off part of an upstairs bedroom to provide the space. A vitreous china tub, lavatory and toilet were included, and later a shower was put in the basement.

In 1960, Hearn decided to leave the plumbing business and open a tavern. He converted the plumbing shop to the Friendly Tavern, which he operated until 1974, with Doris keeping the books. About that time, Hearn decided to subdivide eighty acres he had inherited from his father on State Road 334 west of town. But first he constructed two dams, creating spring-fed Russell Lake.

EARLY RFD CARRIERS NEEDED SUPPORT OF PATRONS ON ROUTES

Had I known what I know now at the time "Past Times" was doing the series on hucksters, I just might have been tempted to include mail carriers along with the other door-to-door salesmen out of the past. Carriers provided veritable horse-drawn post offices in the early years of this century, selling stamps, cards, money orders and the like to patrons along their routes. In fact, to justify the

Zionsville Was Never a One-Horse Town

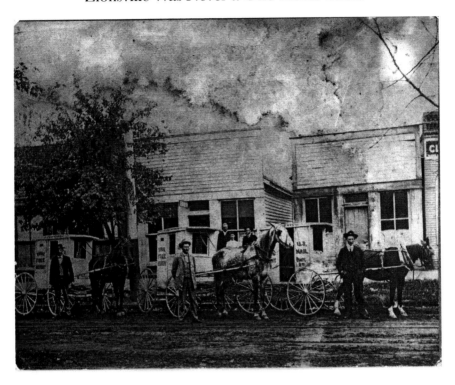

This circa 1905 photograph of the RFD wagons includes carriers (left to right) Joe Schenck, Coanthus Cotton and George Bell. In the background are Postmaster Taylor Harmon, Minnie McDaniel and John Hussey. *Courtesy of the Sullivan Museum.*

RFD (Rural Free Delivery) routes, they were expected to do a brisk business as well as deliver the mail, according to one of the early carriers.

George W. Bell, carrier on Route 28 out of the Zionsville Post Office, made his position clear to patrons in a letter that was printed on the front page of the *Zionsville Times* on December 22, 1910. Under the headline "A Plea to Patrons" and the subhead "George Bell Kindly Asks the R.F.D. Patrons to Stand by Him," he says:

> *Kind Patron:*
>
> *I wish to enter my protest against the habit several of the patrons are forming of visiting the postoffice, purchasing stamps, cards, money orders, mailing letters, etc.*
>
> *The department requires me to make a daily report of stamps sold and cancelled, money orders issued, etc. For the month of October the money order register at the postoffice shows that forty-two money orders were issued*

to the patrons of this route. My report shows that I received twenty-one or just half of the total. This should not be so.

You were anxious to have these routes established by your homes and you should now not only patronize it yourself but see that each member of your family does the same.

As you all know, Rural Free Delivery has not been self-sustaining. I think a great part of this deficiency would be made up if the patrons of the route would give it their full patronage, thus showing the department the true business that is being done by rural patrons.

Now, please remember that I carry stamps, stamped envelopes and postal cards, which I sell to you just as cheap as you can get them at the office. You can also register letters and issue money orders, or can take care of any of your mail matters. With all kindness I would say that the occasions for a route patron to visit the postoffice should be very few.

Extending to all the season's greeting, I am yours for a better, if not the best route in Boone County.

What Mr. Bell failed to consider, or at least didn't mention, was that the post office in town was a great place to run into friends and catch up on all the news. Since there was no house-to-house delivery in town at that time, each family sent someone in to pick up the mail almost every day. Perhaps he should have offered to fill his patrons in on all the local happenings while they purchased their stamps and money orders from him.

We applaud him for making the effort to keep his route alive, but were the products he was offering all that the patrons wanted served with their mail? And did his impassioned plea make a difference?

We'll never know for sure how Mr. Bell's patrons responded, but I do know firsthand that some rural carriers established lasting friendships—and more—with the patrons on their routes. A childhood girlfriend of mine was the daughter of a rural mail carrier out of an Indianapolis substation. Her father met her mother when he was delivering mail to her home. Guess she bought what he was selling.

McGuire's Delivery Team: Hom White and Jack

You could always hear them coming. If it wasn't the clip clop of Jack's hoofs on the dirt streets and alleys, it was the rattle of the wagon he pulled, or

Zionsville Was Never a One-Horse Town

Jack waits patiently for Hom White to begin deliveries for W.D. McGuire's grocery. Posing for the camera are (left to right) Hom, Emil "Little Poke" Lowe and W.D. McGuire. *Courtesy of the Sullivan Museum.*

the cheerful greetings exchanged by "Hom" White, the deliveryman, with townspeople along the way.

Millie, Hom's little daughter, was often perched on the wagon seat, holding the loose reins in her hands and quite convinced that she was driving the wagon. Millie loved to accompany her father on his daily route because she enjoyed people as much as he did, and being an only child, this was an opportunity to be with people.

Hom worked for W.D. McGuire, whose grocery on the brick street provided delivery service that was extraordinary, even as the small community of Zionsville completed the second decade of the last century.

Since few people had phone service in their homes, Hom would head out on his route each morning to collect orders from the customers and pick up eggs or chickens that they might want to sell to the grocer. Some housewives were waiting at the door with a grocery list in their hands but others, who enjoyed the opportunity to chat with the jovial deliveryman, waited until his arrival to put their needs on paper.

After collecting lists from throughout the town, the trio—Hom, Millie and Jack—would head back to the store to fill the order and prepare the due

bills for the customers. If they had given him eggs or chickens, these items were noted as credit on the bill. Then, with the grocery wagon loaded, Jack retraced his steps while Hom delivered the groceries. Finding it easier to walk beside the wagon than climb in and out every few yards, Hom gave the horse loose rein, guiding him only with an occasional word.

Even the needs of the housewife who occasionally forgot some item on the first trip were met. When Hom made her delivery, he would cheerfully note any item she had forgotten for later delivery on what was known as "the short trip." The short trip also was the time when he delivered kerosene to the homes, having picked up the empty cans on his first delivery. All of this activity was accomplished in the morning hours, and Hom could spend his afternoons working in the store.

In those days, all merchants and craftsmen wore white shirts on the job. Since Hom's mornings were so active, he was hot and sweaty by midday. While he was home for lunch, it was his practice to take a bath (in a day when there was no indoor plumbing and people had to hand fill a tub with water and bathe in the kitchen) and put on a clean white shirt and clean pants. The next morning he would wear his afternoon outfit a second time. His wife, Dora, always had his bath and clean clothes waiting, a job in itself since, of course, she had to hand wash the clothes and iron them with a sadiron, as well as heat the water and fill the tub.

Hom's given name was William, the same as his father's, but everyone called him Hom, short for Hominy Bill, a nickname he had picked up as a child. Whenever a friend of his father's, an old man called Hominy Bill, stopped by, he was wearing high boots, which he would remove before entering the house. Little Bill always climbed into the boots and stomped around in them, pretending he was Hominy Bill. And so he became.

Zionsville Never Could Be Called a "One-Horse Town"

Even in its early days, Zionsville was never without plenty of horses. As a farm community, the town regularly accommodated those who drove in from the surrounding countryside to patronize the services provided by local tradesmen and merchants. Likewise, gentlemen farmers who had moved to town but still managed their property in the country drove almost daily out to their farms.

Zionsville Was Never a One-Horse Town

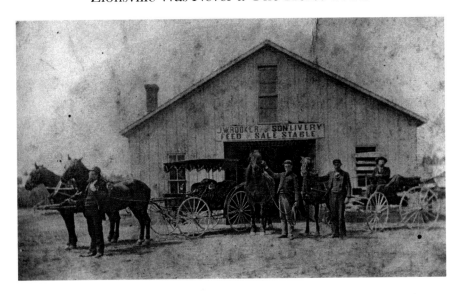

In the 1800s and early 1900s, livery stables were an important part of every community. You could call them horse hotels, but they also rented buggies, surreys and the like. *Courtesy of the Sullivan Museum.*

All this driving was not in automobiles in the last half of the nineteenth century and the early twentieth; it was in buggies or wagons pulled by horses. Also, even though the Iron Horse—whose access was the reason there was a town—brought goods to the community and hauled produce and products from the community to distant markets, it took horse-drawn vehicles to deliver and pick up the freight. So horses, and the vehicles they pulled, were just as essential to the lifeblood of the town as was the train.

From the start, there were harness makers and blacksmiths in plenty, and the blacksmiths did double duty as wheelwrights and coopers. In 1870, and probably for some years preceding that date, Hamilton S. Anderson built wagons and carriages at what is now the southwest corner of Main and Hawthorne Streets. An advertisement in the September 30, 1870 edition of the local newspaper states: "H.S. Anderson has reduced the price on his wagons. Anyone wishing a No. 1 wagon will do well to call and see him. Particular attention paid to horseshoeing."

Also in 1870, the paper notes that "H.S. Anderson proprietor of a tan yard offers it for sale." Perhaps Mr. Anderson had attempted to provide a one-stop service for the horse and wagon customer and found that it was impractical to do everything himself.

In the meantime, Marcellus S. "Sell" Anderson, a native of Germantown, Indiana, had taken a bride in 1863 at North Vernon and the young couple had settled in Zionsville. Whether or not Marcellus was related to H.S. Anderson, the wagon maker, and/or Philander Anderson, Zionsville's first banker, who built the Octagon House, cannot be determined. It is known, however, that Sell had at least two brothers, John T. and Franklin Shortridge, who lived for some years in Zionsville. John moved to Zionsville in 1869 and lived here until 1881, when he moved to Lebanon, where he died in 1911. Franklin, who was listed in the 1870 index of Eagle Township as a wagon maker, was living in Zionsville at the time of his death in May 1913.

In 1883, Marcellus carved himself a permanent niche in Zionsville history by building a factory where he constructed buggies. Choosing the northwest corner of what is now the intersection of Main and Hawthorne across the street from the Anderson wagon works, he hired J. Benson Higgins, a local contractor, in February 1883. According to the account in the *Zionsville Times*, "It [the building] will be 30 x 60 feet, two stories high, of brick, and will occupy the vacant corner near Malin's warehouse. Work will be commenced on it as soon as the weather will permit."

On the ground floor of the building, ironworkers forged the parts for the buggies, and they were assembled and finished on the second floor. From a large door at the rear of the second floor, the buggies were pushed down a short ramp to a loading dock beside the railroad track that ran through town on what is now First Street, there to be loaded on the freight train that would carry them to distant markets.

Later, the buggy factory was owned by William Dwight "Red" Renner, former president of the Zionsville Historical Society, who attempted to have the structure placed on the National Historic Registry. Red said that the walls of the building are three bricks deep and every fifteen feet there is a huge hand-hewn oak column to support the second floor. Six chimneys, equidistant, flank the first floor on the north and south walls. Originally, there was a dirt floor. Joists for the second floor are two- by twelve-inch rough-sawn timbers on twelve-inch centers. There is a double floor with tongue and groove flooring laid at right angles to the horizontal planks it covers.

When Red had the structure appraised in 1975, just prior to purchasing it, Zach Scifres, the appraiser, told him that the floor could bear a load of 150 pounds-plus per square foot. Exposed ceiling beams are of rough-sawn timber.

The forges provided adequate heat for the factory in winter and probably made the work almost unbearable in the heat of summer. Artificial lighting, when needed, would have been provided by kerosene lanterns, Red said.

OF HARNESS MAKERS, HARDWARE, HORSES AND HEARSES

Without the trade plied by Joseph Schenck, blacksmiths and wheelwrights like Sam Essex could not put it all together. You see, Joseph Schenck was a harness maker, and all the well-shod horses and stout-wheeled vehicles in the world would still be two separate entities were they not bound together by the harnesses made by harness makers like Joe.

The Schenck Harness Shop was a near neighbor to the smithy. Located on the west side of Main Street, it was next to the first alley north of what is now Cedar Street. Between the harness shop and Cedar were Sullivan's restaurant, Jones' Meat Market, Knox Grocery and the Home Store, owned by Cruse and Mills.

Joe Schenck cut leather to size from whole hides and made harnesses, either plain or fancy, as the customer directed. Sometimes people would bring in leather that had dried out and he would dip it in an oily solution to make the straps more pliable.

According to two of Joe's grandchildren, Wilma Schenck Sharp and Hubert Schenck, their grandfather was probably a native of Zionsville. His father, Sam Schenck, was a Civil War veteran who settled in the area after the war.

In addition to making and repairing harnesses, a trade that peaked in the spring of the year as farmers readied their teams for the field, Joe also sold some hardware in his shop—pots, pans, skillets and the like. He also bought, sold and traded horses, and was the first rural mail carrier from the Zionsville Post Office, covering his route in an enclosed, horse-drawn boxy wagon.

"I can remember him telling how muddy it was," Wilma said. "Of course, they delivered in all kinds of weather, and he would get stuck. Sometimes he didn't much more than get home than he would have to start out again."

"When I was about six," Hubert added, "he bought a horse off a guy. I happened to be there, and he told me to take it up and put it in the barn up to the house. Somebody got there before me and Grandma was waiting out for me." A six-year-old boy charged with leading a strange horse over the railroad tracks and several blocks up the street was, apparently, not to her taste.

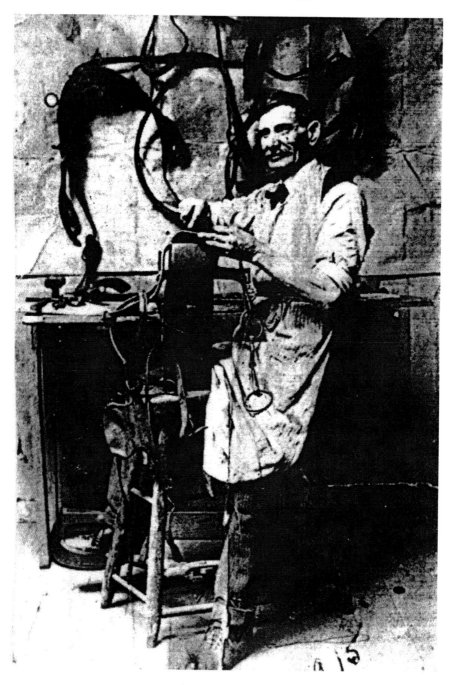

A white shirt with celluloid collar and black bow tie were standard uniform for Joe Schenck, plus the leather apron he made to protect his clothing. *Courtesy of the Sullivan Museum.*

Zionsville Was Never a One-Horse Town

Sometime in the early '20s, Joe won a new Chevrolet touring car in a lottery. Hubert recalled the time his grandfather picked him up in the new car and they drove out in the country toward Traders Point to see about some horses. He thinks of it as "the first time I'd ever seen black people," despite the fact that the Miller family, who worked for Dr. Johns, lived in Zionsville.

"No one ever thought of them [the Millers] as being black," Wilma noted. "They just entered into the community."

Joe did not keep his car long, though. "He didn't like it and sold it right away," Herbert explained. "People were supposed to drive horses, he said."

Rejecting "progress" seemed to be a consistent trait of Joe's. "When radios first came in, he wouldn't listen to them," recalled Wilma, and Hubert added, "He said people were crazy who thought they could hear sound come through it. He wouldn't go in a house where people had a radio and wanted you to listen to something."

At one time, Wilma, Hubert and their three brothers, Elwood, James and Phillip, and sister Crystal (Hine) lived with their parents, Charles and Maude Davidson Schenck, in a house on Second Street. One bedroom of the house was in back, the closest room to First Street, where the train ran. One day Mrs. Schenck had just brought the children's new school clothes she had made in from the clothesline in the backyard and laid them out on the bed in the back bedroom when a train passed. A window was open and the breeze carried in a spark from the train, setting the room on fire and destroying the clothing.

"It was two weeks before school was to start," Wilma recalled. "Mother sewed and sewed and sewed so that we'd have something to wear to school."

On another occasion, Hubert remembered, "Dad came home with a broken arm from cranking a Model-T Ford delivery truck." Mr. Schenck worked for Mills and Cropper and often drove the truck to make furniture deliveries out in the country. The children were "tickled to death" when they were invited to ride along in the back end of the truck.

Charles Schenck played bass drum in the Zionsville band, and when the group traveled to Lebanon for a performance, he would borrow another of his employer's vehicles to make the trip. As was common with furniture dealers of the day, Mills and Cropper sold caskets and operated the local funeral home. Their hearse also provided ambulance service when needed and was just the right size to transport the bass drum.

SAM ESSEX: BLACKSMITH, WHEELWRIGHT, BOOKKEEPER, MANAGER...AND LEADER OF THE BAND

A man of many talents, Sam Essex has lent his name to many stories of early Zionsville. He was a blacksmith, bookkeeper, telephone company manager, trumpet player and Zionsville's first band leader.

Sam's blacksmith and wagon shop was at the corner of Main and Poplar Streets sometime during the 1880s. The skills of his trade were vital to early Zionsville, and his proximity to the business district put him in a convenient spot for farmers to avail themselves of his services while they were in town for supplies.

The gravel roads of the day made it imperative for horses to be shod because gravel would wear their hooves away and cause them to become lame. In winter, they had to be roughshod to enable them to stand on ice. Winter horseshoes were sharpened like spikes at both the toe and the heel so that a roughshod horse had three spikes on each foot—one on the closed toe of each shoe and one on either side of the open heel of the shoe. In

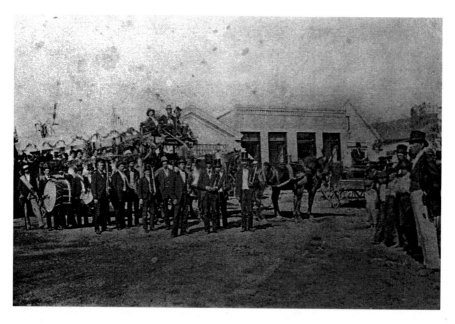

The Zionsville band, under the direction of Sam Essex, is shown here at a Red Men's picnic at Whitestown. *Courtesy of the Sullivan Museum.*

addition to outfitting horses with the proper shoes, the blacksmith also did any welding that was required by his customers.

As a wheelwright, Sam tightened the fit of the metal rims on wheels by removing the metal "tires," heating them and replacing them while they were hot. When the metal cooled, it contracted, ensuring a tighter fit. This was a service generally required in summer, when the wooden wheel dried out and shrank. Until he could get to a wheel shop, the farmer had a stopgap procedure he could do himself. Leaving the metal rim in place, he would soak the wooden wheel in a pan of linseed oil to expand it.

Since Sam's father, William Essex, was a carpenter who also made wagon wheels, it is believed that Sam learned his wheelwright skills from him, moving with his trades to Zionsville while his father served the Eagle Village area.

When the Essex family built a house at what is now 125 North Main Street, just north of the blacksmith shop, their friends asked, "Why did you build a house so far out of town?"

Fire damaged the small house, and a new house was built on the same site in 1892. It was at that location that their two daughters were born: Eloise (Harkins) and Joyce (Smith). Eloise had no children and Joyce had one daughter, Gayle Downey. Gayle's son, Robert, started out on his great-grandfather's trumpet when he began playing with the school band.

In 1891, when the Northwestern Gas Company was formed to serve Zionsville from five gas wells northeast of town, Sam Essex was bookkeeper for the firm. By 1901, the gas supply had been depleted, but Sam soon associated himself with another utility, the local telephone company, which, sources say, must have come into being about 1905 or 1906. The telephone exchange was housed in a two-story building east of Essex's blacksmith shop.

Although manager of the local concern, Sam was always ready to respond, with the assistance of a lineman named Kinnaman, to the service needs of his customers. Anna Essex Crane recalled that her uncle wore felt shoes, over which he placed rubber overshoes when working in the field. If it were necessary for him to climb a pole, he donned spurs that were fastened to each shoe and secured by straps around the ankle and just below the knee of each leg.

At the time Sam was manager, each community had its own small company that served it and its environs, installing the poles and lines for service and keeping the equipment in repair. At some places where the territory of two

companies overlapped, there were two sets of poles and lines along the roads. Zionsville customers had to pay a long-distance charge to phone the county seat at Lebanon.

Whitestown also operated its own phone company, using poles that were cut from the nearby woodlands. According to one reliable source, the Whitestown poles sprouted twigs with leaves in the spring of the year, something Zionsville's poles did not do.

But, despite its more primitive poles, Whitestown accomplished a feat Zionsville did not. The Whitestown manager, George Washington Byrkett, struck a deal with the Lebanon telephone company whereby his customers had free service to Lebanon except when they were in a hurry. For service under press of time, they had to pay a charge.

A musician who played the trumpet and the alto horn, Sam was leader of the Zionsville band before the first bandstand was built in Lincoln Park. Helen Shaw McKnight's father played cornet and tuba in the early band while Sam was a member. She believes that one of the places they played was in a bandstand at Zion Park during camp meetings.

ZIONSVILLE STOPS WERE ON THE GYPSIES' ITINERARY

Gypsies! There was an aura of mystery that surrounded these nomadic people that many found fascinating. Their lifestyle—the direct opposite of the way most people chose to live—nevertheless intrigued. They at once repelled by their flaunted disobedience of laws, disgusted by their rejection of health standards, distressed by their disregard of the educational system and at the same time evoked that same sense of tingling anticipation of the unknown as an impending storm.

Gypsies had made periodic visits to Zionsville and the surrounding countryside for as long as anyone could remember. Their mode of transportation, as their appearance, changed with the times, but they remained instantly recognizable and their arrival was always broadcast with amazing speed.

Myron Crane recalled, "They would come every two or three years. Word would get around awful fast if a bunch of them happened to come in."

Meredith Smith agreed, "I can remember them coming through town and everybody would lock their doors."

Zionsville Was Never a One-Horse Town

"About every summer, a group of them would come past the farm," Red Renner added. "If we saw them coming, we tried to make sure they kept going. My folks would never let them light."

Annie Miller remembered, "In the early '30s, they used to come through town in caravans. And if they came in the store, my dad said to watch 'em. It was difficult because there were so many. He always locked the door on one side so they would have only one door to go out."

When they came to town, Mildred Ogborn recalled, "Glenn would call home from the drugstore and say, 'Take your little girl in. The gypsies are in town.'"

Glenn's fears seemed justified, since the word around town was that they would "steal anything they could get ahold of—even a child." You never knew what they were up to.

Recollections of incidents involving gypsies date back to about 1909 or '10, when Myron Crane said that gypsies came to town in horse-drawn wagons and pulled into the vacant lot beside the Alford Monument Shop at the southwest corner of Main and Pine. Myron and several of the town boys in their early teens were intrigued by one wagon that was covered with canvas. Gypsies kept going in and out, and the boys wanted to know what was inside. They finally persuaded one of their number to peep. The boy came away with the proverbial egg on his face, but in this case the egg was actually milk. It seems that a gypsy mother was nursing her baby and rewarded the peeping Tom with a well-placed sample.

The gypsies had "skills" that they tried to market. They would offer to tell your fortune or bless your money for a coin or two. These activities, people believed, were diversions to hold your attention while one of their band helped himself to some of your property. But no one recalls actually missing anything after they left. Perhaps the wariness of the locals protected them.

If they came on the Renner property, Red remembered, "When I was old enough to handle a shotgun, I'd sit on the porch with the gun in my lap while my mother talked to them."

When a gypsy stepped behind the counter at Ogborn's Drug Store, offering to bless the money in the cash drawer that had been opened to make change for a customer, employee Hom White responded quickly. He slammed the drawer shut on the gypsy's fingers.

About 1931, three gypsies—two men and a woman—stopped by the garage of mechanic Clarence Beck, who lived on Mulberry Street. Bob Bender was there, and he recalled that the gypsies offered to bless Beck's money for about fifty cents.

"He got his billfold out," Bob recalls, "and held it in his hand while the gypsy placed one hand on top of it" and repeated the blessing in a tongue the local men did not recognize. Both Clarence and Bob watched carefully during the procedure, but after the gypsies left, Clarence thought a bill was missing. Upon closer investigation, he found it in the hidden compartment where he had originally placed it and then forgotten about it.

Should anyone forsake caution in his relationship with the gypsies, he was certain to be taken to task for it later by a loved one, as Irene Markland related. "One time a group of gypsies came to our house. I was too small to remember, but I've heard the story many times. My mother let them in and gave them food. They didn't bother anything. They just left. But my dad gave her a terrible lecture when he found out."

SERVICE INDUSTRY GREW FROM HUMBLE BEGINNINGS

TELEPHONE OPERATORS WERE ORIGINAL CITY DIRECTORY

When Laura Moore (Bowers) went to work for the Citizens Telephone Company in Zionsville in 1930, the firm was located in a dwelling at Second and Pine. The switchboard, a telephone booth, the office and rack room occupied the northeast corner of the house, with living quarters on the south side for the lineman.

Opal Atkinson was the night operator, and during the day Janie Trout, Harriette Pittman, Mildred Thompson and Effie Stansbury handled the calls. Laura, as a relief operator, was paid ten cents an hour, but she earned thirteen cents each hour she filled in for one of the regulars. During the Depression, they each received thirty dollars per month. One week an operator would work from 7:00 a.m. to 1:00 p.m. and the next week from 1:00 to 4:00 p.m. and 5:00 to 9:00 p.m.

Gerald Higbee came to Zionsville as a lineman in 1927 and lived in the south side of the house until the structure was moved to the northeast corner of Poplar and Beachwood Lane to make way for the building that still occupies the Second Street corner. Higbee added an alarm system for the volunteer fire department. When a fire was reported on the line, the operator had to push a button to summon each fireman. Often the person reporting the fire was in such a panic that the operator couldn't get the name. But she could tell which line the call was on, and it helped if she could also recognize the voice. The bank alarm was also attached to the switchboard.

In the early 1930s, the telephone office was in this house. Shown in front are five operators (from left): Opal Atkinson, Laura Moore Bower, Mildred Conrad Thompson, Bessie Smith, Harriette Shaw Pittman and lineman Gerald Higbee. *Courtesy of Laura Moore Bower.*

Although there were private lines, there were also many party lines, with some serving as many as eighteen customers during World War II. Two customers on one party line used to phone each other every day, but instead of ringing directly, they always called the operator, who had to ask the caller to hang up so that she could ring the other party. On one such occasion, a somewhat flustered new operator was heard to say, "You ring up and I'll hang for you."

The operators' patience was tested on many occasions, as in this routine instance with the town drunk. When he was inebriated, he would come in to use the public phone booth to call his lawyer in Lebanon. When the attorney came on the line, an operator had to go to the booth and put the receiver to the inebriate's ear and tell him two or three times to talk.

One customer, a merchant, always preceded the number she wished to call with a cussing for the operator, no matter who it was. Laura found this particularly hard to understand because the woman attended her church and often chose as her solo with the choir "Have Thine Own Way Lord."

Night operators were permitted to sleep on a cot pulled up under the switchboard, after setting the night alarm. When the alarm sounded, she had

48

to switch it off and rise to her knees to plug in the call. One time, when three operators were sharing one cot that was somewhat wider than a single bed, the piercing blast of the night signal so startled one that she upset the cot.

Since a subscriber seldom called by number, the operators had to memorize all of the numbers, no little task since there were several rural party lines with ten or twelve subscribers. Local doctors always called the switchboard to leave word where they could be reached.

Union Telephone Associated Companies bought Citizens from United Telephone of Monticello about two months after Laura joined the firm, and sold it to Indiana Bell in 1953. However, the Citizens name was retained until the Bell purchase.

Shortly after the Bell acquisition, a supervisor reprimanded Laura for her informal habit of calling customers by their first names. In the middle of Laura's explanation, a local resident came in and Laura greeted her with, "Good morning, Mrs. _____."

"What the hell's wrong with you, Laura?" was the startled response, in perfect illustration of the point Laura was trying to make.

OF A GIRL, A HORSE NAMED PRINCE AND SMITH BROS. TRADE PALACE

Defying all predictions of the oldsters in the community that "that Smith girl's going to be killed for sure," Irene Smith (Markland) lived to the age of ninety-seven. Not only did she survive, but so did her memories of the special times of her youth in Zionsville.

Reasons for the dire predictions of her untimely death centered on a horse named Prince. As a teenager, Irene would hitch Prince to a buggy and Bob Carter would hitch a horse to a buggy and the two would race on Pine Street. Sometimes she would put a bridle and saddle on the horse and ride him around town. Once, and only once, did she take a girlfriend up behind her. Prince turned his head, looked at her and then bucked and threw her friend to the ground. He was, unquestionably, a one-woman horse.

The relationship between the girl and her horse had been developing for a number of years. When she was no more than five or six years old, Irene used to ride in the grocery wagon behind Prince when her father, Bert Smith, and his brother, Percy, owned Smith Bros. Trade Palace at the corner of Main and Cedar Streets. The little girl would accompany the deliveryman on his

Brothers Bert and Percy Smith owned Smith Bros. Trade Palace at the corner of Main and Cedar Streets. The store sold dry goods on one side and groceries on the other. *Courtesy of Martha Graves.*

Service Industry Grew from Humble Beginnings

51

rounds of the town, and when they returned to the store, the man would dismount, throw the reins around the whip and tell Prince, "Take Irene home." The faithful bay would take his charge across the railroad track to the barn that still stands behind the house at 220 West Cedar Street.

In the wintertime, Irene recalled, "We used to hitch the horse to the sleigh and drive clear to Noblesville through the snow to visit my grandparents. Father would heat bricks on the stove and wrap them in blankets to keep our feet warm."

Bert and Halcy Dove Smith, Irene's parents, moved to Zionsville soon after their wedding in 1893, and settled into a home at what is now 260 West Cedar Street (there were no house numbers in those days), where Irene was born on September 24, 1897.

The Smith Bros. store had a grocery on the north side and dry goods on the south side. Shoes, undergarments, yard goods, patterns, thread, needles, linens and household miscellany were sold in the dry goods section. Most of the women made their own clothes and the clothing of their families, and Halcy Smith was no exception. She made most of Irene's clothing, doing much of the stitching by hand, although she did have a sewing machine that she used occasionally.

The grocery was stocked with big barrels of baking soda and flour, Irene recalled. "The sugar used to be in massive hunks. Bulk merchandise was put in a brown sack and weighed by the grocer who would fill the order of each customer in turn as she waited at the counter. Everyone paid cash for groceries, and few males shopped."

A lover of sweets, Irene recalls that, as a small child, she once dipped her hand into a barrel she thought contained powdered sugar, only to be shocked by the bitter taste of baking soda.

There was a variety of fruits in season, with bananas brought in by the stalk and hung until the grocer cut off the number required by a customer. Oranges were sold only at Christmastime.

There was no refrigeration, and cured meats hung in the back of the store, cut to order on the wooden butcher block, with a whetstone nearby to keep the knives sharp. Whole cheese was also sliced on the block. Cottage cheese—called smearcase—eggs and milk were brought in from nearby farms and exchanged for groceries. Dill pickles were sold individually.

A glass case held candy that was sold in bulk—all kinds of stick candy, lemon drops, licorice, hoarhound, rock candy, jelly beans, Boston baked beans and more.

Ogborn Store Sold Drugs and More in Early Zionsville

"Just let a Zionsville boy come down to New Augusta and another girl is gone," muttered the residents of Zionsville's neighbor to the south when last century was but a couple of decades old. And we suspect that no one muttered louder than the jilted swains of Pike Township.

Young Glenn Ogborn was a good example of a promising young man of the village who brought his bride across the county line. Already in possession of a teacher's license, Glenn had been convinced by local pharmacist Jeff Knox that he should become a pharmacist instead of a teacher, so the young man enrolled in the college of pharmacy at Indianapolis.

First employed in a drugstore on East New York Street and later in one at Thirtieth and Clifton in Indianapolis, Glenn met and courted Mildred Artman of New Augusta, a piano teacher in that community. The two married in May 1921, and in June they bought the drugstore from Mr. Knox, who wanted to retire, and the house on West Cedar Street where Mildred, widowed in 1973, lived with their daughter, Martha.

John Hodge, who worked for Knox, stayed on to help Glenn as a pharmacist, for the hours were long: 6:00 a.m. to 10:00 p.m. six days a week and 8:00 a.m. to 1:00 p.m. on Sundays.

"Dad opened early each morning," Martha said, "to accommodate the people who wanted to catch the interurban. They would want a morning paper or a candy bar to take along."

When Elizabeth Jeffries got an associate's license in pharmacy, she went to work for Glenn, and later Ronald Brinley was licensed and joined him behind the prescription counter. The mortars and pestles that have become symbols of the pharmacist were more than merely symbols in those days when the druggist filled his own capsules and mixed liquid drugs to doctors' prescriptions.

There was no gas to cook with in the store, so Mildred made the chocolate syrup for the soda fountain at home, by the bucketful, and Glenn would take it to the store, add simple syrup and make "some of the best sundaes and sodas around," according to their satisfied customers. In the early '30s, gas came to town, and a hot plate was set up to cook the syrup at the store.

Originally, the store was heated by a stove around which the town loafers would congregate, availing themselves of strategically placed spittoons. Glenn soon tired of cleaning up their inaccuracies. He took out the stove

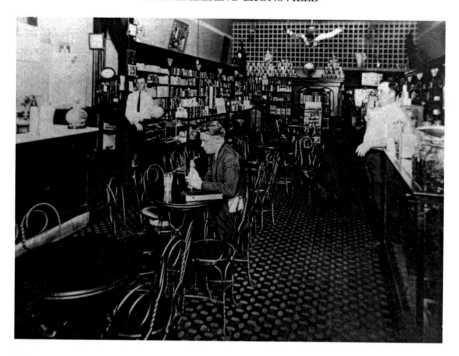

The soda fountain and, later, a lunch counter were big attractions at Glenn Ogborn's Corner Drug Store, where the mortar and pestle were still essential to the pharmacist. *Courtesy of Mildred A. Ogborn.*

and put in "a one-lung furnace," Mildred said, "with the big hot air register to heat the store that was then half the size it would later become."

He also put in a lunch counter along the north wall and served plate lunches and homemade pies. Each day a special would be featured, such as beef Manhattan, or beans, ham and cornbread. There was also a special pie featured each day. On Friday it was gooseberry, and a man who worked at Pitman-Moore had a standing order for a piece of gooseberry pie each Friday.

Linnie Hull, Myrtle Smith and Jessie Houser were cooks, and Blanche Wiggans made the pies, all in the kitchen at the northwest corner of the store. Breakfast was also served, and Glenn hired Kenny Klinger to wait on the customers who occupied the ice cream tables and booths nearby.

A certain man who stopped at the lunch counter each Sunday morning was given to boast, "If they had any bananas in here, I'd buy everybody a banana split." This went on for some time until everyone was tired of hearing it. Then one Sunday, they were ready for him with a bunch of bananas

stashed under the counter, which was summarily pulled out in response to his standard offer. The perfect squelch!

Although Mildred took only a few piano students after moving to Zionsville, she made use of her talent by playing piano, and later organ, for the Methodist church. She recalls that in the 1940s or '50s, a speaker was placed in the bell tower of the church (then at Main and Poplar) and organ music, especially at Christmastime, was broadcast for the enjoyment of all within earshot. She also played at the local funeral home and occasionally filled in for Helen Brock, who played for silent movies at the Zionsville theatre. "We played the piano the best we could to fit the movie," she recalls, acknowledging that the pianist improvised as she watched the movie for the first time right along with the audience.

Clerking and bookkeeping chores also kept her busy, and she was usually the one who drove to wholesale houses in Indianapolis for supplies. "They didn't have trucks to deliver smaller drug orders," she recalled.

The drugstore sold wallpaper and paint in addition to drugs and sundries, and was the drop-off point for Progress Laundry and for Foster Film at Lafayette. It also carried Hess stock feed (a tonic for cattle) and school textbooks, and was also a gathering point for those in search of news—local, state and national.

"There were no radios," Mildred noted, "and at election time the people would come into the drugstore until it was solid with people. They would pass the hat and someone would go to the telephone and get information on how the election was going. About ten or eleven o'clock, as the final outcome seemed certain, those who supported the losing party would gradually leave."

Lew Daugherty's Livery Stable Provided Diversified Services for Village Residents

What one business was the forerunner of today's taxicab, parking garage, auction house and feed store?

You guessed it. It was the livery stable, in general, and the L.M. Daugherty Livery, Feed and Sale Barn in particular.

Lew Daugherty was the father of Paul Way's late wife, Alice. He owned the business, Paul recalled, between 1918 and 1925, a period when automobiles were rapidly replacing "Old Dobbin" as the prime means of transportation.

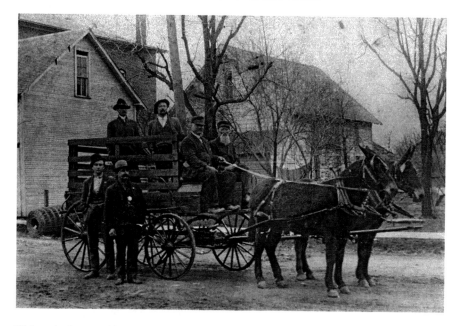

This mule-drawn calf wagon would ordinarily carry calves, hogs or cattle to butchers. Used as a photo prop here, it is driven by its owner, L.M. Daugherty. Bill White, town marshal, stands on the right. *Courtesy of Paul Way.*

Because of this, livery barns had become more diversified than when they originally served an exclusively horse-driving public.

Lew's barn provided a home away from home for horses whose master or mistress came to town on a business or shopping trip. An attendant would unhitch the animal and put it in a stall, where it would be given hay, grain and water. Occasionally a horse was boarded for a week or more while its owner traveled some distance by train.

If anyone without a horse needed horse and buggy transportation, the livery stable would provide that service, much as a cab company would today.

Frequently a farmer would have animals to sell, and he would hire the local auctioneer, Arthur Spaugh, to sell them for him. The animals to be sold were delivered to Daugherty's barn, where they were placed in stalls until the auctioneer was ready for them. One at a time they were brought out into Cedar Street, where a circle of prospective buyers had gathered around the auctioneer.

Myron Crane remembered that about 1921, James Ellis Van Horn, a relative of the Hypes family, brought a shipment of Jersey cattle into

Service Industry Grew from Humble Beginnings

Zionsville by train. The animals were taken to the livery barn and sold at auction in the street in front.

A unique auction of hunting dogs was recorded on the front page of the *Zionsville Times* of October 7, 1920:

> *The dog sale of Dr. J.C. Reiber Friday night drew the largest crowd that has ever been in the sale pavilion here—in fact they could not all get inside. Thirty-one dogs were sold and the total was $622.00 or an average of slightly over $20.00. Buyers came from all over the country and the bidding was spirited. The newness of the sale brought many spectators. Dr. Reiber expects to continue his kennels here.*

The dogs, guessed Myron Crane, were probably black and tan hounds— good coon dogs. Coon hunting was a popular sport, and a good coon dog would bring $100. Dr. Reiber, a veterinarian, bred hunting dogs in a kennel on property where he lived in a remote area of Willow Road.

There were always boys around the livery stable to do "flunky" jobs, according to Paul Way. One that he especially remembered was a tall, gangly lad who had picked up the nickname "Brom Bones" White. Another who helped around the horses was Old John Eggers, who made his bed each night on the couch in the office. When Old John felt the need for a bath, Paul recalled, he would take it in the drip of the barn, clothes and all.

Another side venture of Lew Daugherty was his calf wagon, in which he would pick up hogs, calves or cattle to be delivered to one of the local butchers: Jim Jones or Carl Rosenstihl and Otto Louth. The butchers, whose shops were on Main Street, had slaughtering facilities along what is now Temple Avenue, the road that runs along the north side of the golf course. A man named Bradley would haul their refuse to his reduction plant off Ford Road, just south of Eagle Creek.

Paul recalled a charming story his wife, Alice, used to tell of a visit that she made with her father to the Rosenstihl & Louth butcher shop. A small child at the time, Alice became terrified when she heard Otto Louth instruct her father, "You get the kid and I'll skin it." Only later did she learn that her father was to bring a baby goat to the butcher.

DR. ELMER JOHNS BEGAN PRACTICE
AND MARRIAGE IN 1897

Dr. Elmer Johns was born in 1873, attended grade school at Jolietville and high school at Zionsville, taught three years at the Beeler-Goodnight School, studied medicine at the Illinois Medical College and entered the practice of medicine at Zionsville in 1897, the same year he married Edna Grube. Miss Grube was the step-daughter of Dr. W.Y. McNutt, with whom he started a practice.

The addition of Dr. Johns gave Zionsville six practicing physicians at the time. Doctors Alford, Cotton, Lee, McNutt and Shelburne had already established practices. Given Zionsville's population in 1900, that would mean each doctor would serve 127½ patients, or if the calculation were based on the Eagle Township population of 1,883, each would have approximately 313 patients. Since transportation for the doctors was by horseback or buggy

Immaculately dressed, as always, Dr. Elmer Johns took time out from his busy practice to pose for the photographer at the desk in his Main Street office. *Courtesy of the Sullivan Museum.*

and house calls were expected, an argument could be made that six doctors in a community that size was not excessive.

For a September 18, 1947 article in the *Zionsville Times*, probably written by Editor Bernard Clayton, the doctor was asked what his fees were when he began his practice: an office call was fifty cents, a house call cost one dollar and delivery of a baby was five dollars. From the income generated, a doctor had to maintain a stable with two to four horses.

There were few hospitals in 1897, and Clayton reported that people living in Zionsville never thought of going to one. Major surgery was performed in the doctor's office or on the kitchen table. The editor concluded, "Those were the years marking the hey-day of the country physician and many people regret that only a few remain."

In 1908, Dr. Johns purchased his first automobile, a four-cylinder Flanders, but as insurance in case it refused to run, he kept several horses.

His beginning years in Zionsville were hard: fees were small and sometimes hard to collect, roads were bad and sometimes the doctor must drive a horse and buggy five to ten miles out in the country on a cold, wintry night, earning at the most a five-dollar fee.

Editor Clayton observed:

> *Benjamin Franklin once said, "take care of your business and your business will take care of you." Doctor Johns is living proof of that epigram. By close attention to his profession, by rendering prompt service regardless of the hour, and by being a good collector and business man, Doctor Johns is as well-to-do as any business or professional man in this community.*
>
> *Like the late Doctor M.H. Foster, Doctor Johns is an immaculate dresser. His shoes are always shined. Not a single wrinkle shows in his tie and the shirt looks as if it just came out of a box. You know by the appearance of the suit, that it was made to fit the owner. The car he drives does not show any trace of dust or mud. It was polished this morning.*

For a number of years, the doctor was also the local health officer, and he had been the attending physician at the Baptist Home for more than forty years. He was a member of the staffs of both Witham and Methodist Hospitals.

When he died on December 25, 1961, at the age of eighty-eight, he was survived by his wife of seventy-four years and several nieces and nephews, two of whom also were physicians.

PITMAN-MOORE'S DR. REGENOS WAS RESPECTED BY WORKERS, TOWNSPEOPLE

Dr. Showley Regenos was one of those rare people who stay focused their entire lives, from cradle to grave. This unwavering sense of direction led him, at times, to appear somewhat aloof, but that was more illusion than fact. Fellow employees during his thirty-five-year career at Pitman-Moore and its successor, Allied Laboratories, Inc., attest to that truth.

Harland Pitzer, whose own career at Pitman-Moore spanned forty-five years, was there when Dr. Regenos arrived, and remembers him as a good friend.

Cora Templin Turley worked in the office while Dr. Regenos was director. "I dearly loved that man," she says, noting that she learned to anticipate his moods. "If he came in with his head down and was frowning, you knew to keep your mouth shut," she recalls, but "if he came in with his head up high and smiling, everything was all right."

Aletha Hill Phillippi began working at Pitman-Moore in the summer of 1937, as a replacement for vacationing office employees. When vacation ended, she stayed, working until late 1940, shortly before the birth of her first child. The doctor had a good sense of humor, she recalls, noting that on one occasion he came up to her and said, "C'mon, let's get out of here." When she obediently followed him outside, she found herself in high-heeled shoes, holding one end of a tape measure as he measured the site of stables he was planning. The resulting structures and the horses that occupied them were essential elements to the planned production of horse serum.

Regenos's tenure with the firm began in January 1919, and ended with his retirement in 1954. When he arrived, Pitman-Moore was located on the east side of Zionsville Road, north of the present location of Pizza King. The laboratories were devoted entirely to the production of hog cholera serum, on their way to becoming the largest producer of that serum in the world.

The young vet had been hired because the growing Pitman-Moore Company was planning to expand its facilities south of Zionsville. The firm intended to produce a variety of biological products, and its new employee was well qualified to help with the task.

Before enlisting in the U.S. Army during World War I, he was employed by Parke, Davis and Company in biological production. He left that position to enlist on August 13, 1918, only three months before the Armistice was signed. He was commissioned as a second lieutenant and assigned to the SS

Floridian, with six hundred horses aboard, on November 29, 1918. He was discharged on January 9, 1919, with the rank of major.

The Regenos family—the doctor, his wife Frances and two daughters, five-year old Jeanette and three-year-old Iris—moved into a house north of 106th Street and almost across the street from the plant. There was land for Frances to have a garden and for Showley to raise some chickens. But the shy little girls were somewhat isolated from the children in town.

Iris remembers her father as good to his children, but strict. They always had chores to do: working in the garden, helping with the chickens. It was their job to climb up to the roost and gather eggs, sometimes reaching under the hens to do so.

Her father, she recalls, was able to do almost anything he set his mind to. He usually had some woodworking project underway; between times he was asking her mother, "What do you want me to make?" or "How many do you want?"

The Regenoses were avid bridge players, and for many years they played regularly with a group of local couples, including the Inwoods, the Fergusons, the Brendels and the Harveys.

Food Locker Flourished in 1940s and 1950s

Back in the days before home freezer chests or large refrigerator-freezer compartments were de rigueur in most homes, freezer plants such as the Zionsville Locker Plant sprang up to fill the need for a better way to preserve both meat and garden produce.

Perhaps the way to the Locker Plant's enthusiastic reception when it opened its door for the first time in 1941 may have been paved by the introduction to the community of Birds Eye Frozen Food products by local grocer Jeff Knox near the end of the previous decade. The public had witnessed firsthand the advantages of Clarence Birdseye's quick-freezing process, which sealed in freshness that wasn't to be found in early forms of food preservation.

When the plant was constructed in 1941 by John Warner and associates in the 300 block of South Main Street, where Zionsville Antiques now stands, only 144 lockers were available for rent. The capacity was increased by 65 in the first two years, but that number still did not meet demand, so a new addition was added, stretching the facility south to Hawthorne Street. The addition, used exclusively as a locker room, increased the plant's capacity to 1,154 lockers.

The Zionsville Food Locker spanned the period between dependence on home preserved food and in-home freezer compartments or chest-style freezers. *Courtesy of the Sullivan Museum.*

Because of early financial difficulties, according to a report carried in the *Zionsville Times* of March 2, 1950, the business was reorganized and Frank Donner, one of the stockholders, became manager in 1948. Between then and 1950, the facilities were further improved with the addition of a smokehouse and a curing room.

The new facility served as a public relations tool for the town. According to the *Times* report, the Locker Plant had drawn many from outside the Zionsville community to town, where they became acquainted with other merchants. Editor Bernard Clayton noted that families from Indianapolis, Lebanon, Carmel, Brownsburg and Whitestown were among those who rented lockers.

As varied as the locations of those who rented lockers were the sources and varieties of meat that they stored. There was bear from Canada, elk from Montana, deer from Colorado, fish from the Gulf and pheasants from South Dakota. The plant made it possible for farmers to slaughter at any time of year and for those with excess fruits and vegetables to process them during the harvest, giving them a nutritious, balanced diet year-round.

One firm that profited considerably from its proximity to the plant was the Jones Slaughter Plant, built several years before by Perry Jones. Farmers

would haul their livestock to the slaughterhouse where, in several hours, it was prepared for storage at the locker plant.

But the locker plant was not just a storage facility for those who brought in their own meat or produce for freezer storage and then gradually removed it for their own consumption. Those who neither raised livestock nor produced vegetables could visit the plant to purchase the surplus of others.

Among those who worked at the locker was Geneva Woodrum, who, with her husband Willis and six children, lived next door in the late 1940s. While her mother worked at the food locker cleaning and dressing poultry and wrapping meat, her daughter Marge (Curry) recalled for an earlier "Past Times" column that their aunt stayed with the children.

"Sometimes John Warner at the food locker would let us come over and watch when they put the dead chickens in a machine that took off all their feathers," she recalled.

When the Woodrums lived in the house where Avalon Jewelers is today, Cornelia Brouhard lived in a house on the site of the beauty salon where Marge now is a hairstylist. Across the alley, where Bender's Square shops stand, was the Metzger Lumber Company. The Zionsville Locker Plant occupied the lots between the Woodrum home and Hawthorne Street.

Across Main Street was a wooden building that had once been the top floor of Zionsville's first schoolhouse, which sat on the northeast corner of Main and Poplar. From 1946 to 1955, the structure was home to Tubby's Cleaners, owned by Allen J. "Tubby" Sanders and his wife Jeanie. In 1954, the Brouhard home and that of the Woodrums were razed and the Sanderses built the present building, occupying the north half as their cleaning plant and renting the south half to Tom Harris Chevrolet dealership.

When Harris moved to a larger building, Dr. Messenger located his office there for several years, until the Sanderses decided to open a laundromat in that space.

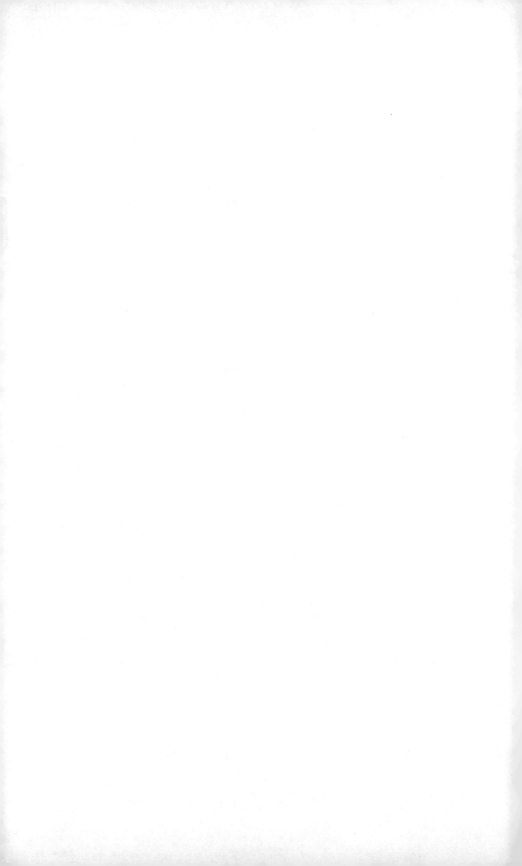

PARK ACTIVITIES DREW VISITORS

LAKE COMO: AN ATTRACTION AND A THREAT TO ZIONSVILLE

In Chapter Two, I began the story of my visit with Euva Harvey, ninety-one, and her one-hundred-year-old sister, Nola Huckleberry. The two ladies, along with their sister, Edna Lovett, and brother, Dr. Ralph Harvey, were the surviving children of Stephen and Laura Johns Harvey, parents of ten.

Euva was born in the family home that stood at the southeast corner of Cedar and Fifth Streets. Years later, the structure was moved to New Augusta. At the time the Harvey family lived in the house, there was a stable at the back of the lot where Stephen Harvey kept a team of horses he used for log hauling. As farmers in the area cleared their land, he would be called in to haul away the logs, sometimes shipped from Zionsville by train.

One of his jobs was helping dam a stream or branch that flowed across the northwest corner of Zion Park to create Lake Como, the charming recreational lake on property that now belongs to Zionsville Community Schools. A popular spot for boating, with a trolley cable car suspended above it, the lake has long since been filled in.

Lake Como became a terror to Laura Harvey. Although swimming was not allowed, the older boys in the community found it too great a temptation to resist. Birgle Harvey, the eldest Harvey son, was not as old as most of the swimmers, but he was at the age where "he wanted to do what the big boys did," according to his sisters. Not able to monitor her son constantly, Laura told her husband, "We've got to get out of this town."

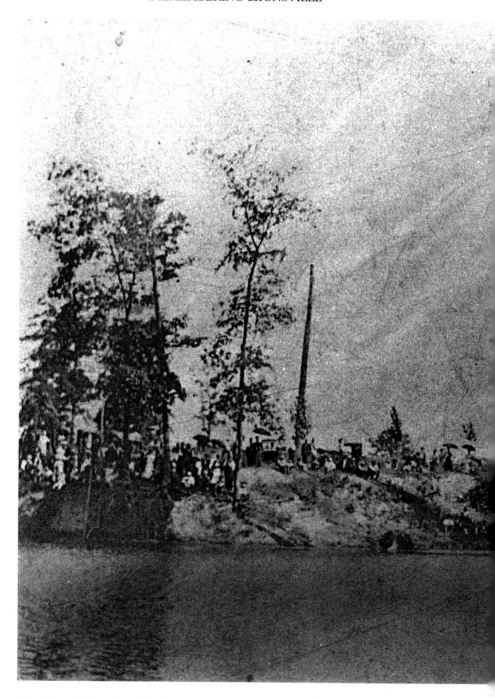

Lake Como in Zion Park offered boat rides, a tight-wire act and Kerguland Island, where a bandstand was located. For a short time, there was also a cable car ride across the lake. *Courtesy of the Sullivan Museum.*

Park Activities Drew Visitors

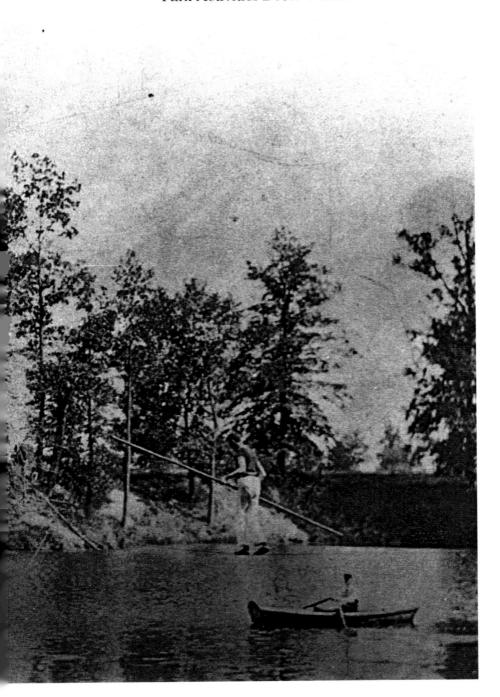

The family moved first to a parcel north of Indianapolis, but by the time Euva was ready for sixth grade, they had returned to a farm on Zionsville Road, south of the town.

Fortunately, not everyone felt the way Laura did.

Zion Park was the site of the Zion Park Assembly, or Camp Meeting, as it was often called by the local people, held every August from 1891 through 1922. The event lasted over three weekends and the two weeks in between. It brought thousands of people to town to attend lectures by famous orators or preachers, hear band concerts and other musical performances, watch plays or laugh at comedians. Many of the speakers and other entertainers traveled on the Chautauqua circuit out of Chicago.

The visitors came by train, wagon, buggy, on horseback and, later, by interurban. Most of the events at the park took place in a very large tent, known as the Tabernacle, but there were other buildings. One was for food service, and another was a small house to provide a place for visiting ministers to stay.

Small tents could also be rented by local families who used them as a place to rest between activities and as a place to meet and share the picnic lunches they brought along. These little tents were so popular that regular attendees hired a local contractor to pour a concrete pad so the tent would have a floor. Some families even permitted their children to spend the night in the family tent if they were accompanied by an adult member of the family.

Lake Como boasted a small island, Kerguland Island, just large enough for a bandstand. Many of the visitors would take a blanket to lie on at lakeside while they listened to music.

A baseball diamond in Zion Park was a popular place not limited to Camp Meeting. It was actively enjoyed by the town's male population even after Zion Park closed.

ORIGINAL LINCOLN PARK BANDSTAND REMEMBERED

As she watched the new bandstand take shape in Lincoln Park, nostalgia for courting days swept over Claire Breedlove Lovett. It was soon after she finished high school and before her marriage in 1932, when the concerts she most vividly recalls were held each Wednesday night in the original bandstand. Townspeople and visitors alike were drawn by them to the business district each summer.

Park Activities Drew Visitors

The first bandstand in Lincoln Park was the site of concerts on Wednesday evenings during the summer. Residents would drive down early in the day and leave their cars on the streets surrounding the park for concert seating. *Courtesy of Aletha Hill Phillippi.*

"It was a big shopping night...a neighborly night," she recalled. "All the stores stayed open and you could hear the music all over town. People would come in from all the neighboring communities—New Augusta, Whitestown, Lebanon, Carmel—and the sidewalks were full of people." Earlier in the day on Wednesdays, townspeople would park their cars around the block that formed the park so that they would have good vantage points in the evening.

At the time Claire remembered best, the baton was in the hand of Ira Stephenson, but Sam Essex preceded him as conductor. On the roster of band members at one time or another were the following: Gail Vandover, trumpet; Kay Cook, clarinet; Dr. Everett Hurst, baritone and bass; Ira Kinnamon, alto horn; Herbert Smith, baritone; Bill Smith, drum; Elwood Schenck, snare drum; Bert Moore, cornet; Bert Mills, valve trombone; Cleo Stephenson, slide trombone; Forest Hull, clarinet; Howard Ditzenberger, clarinet; Helen Shaw (McKnight), trumpet; Catherine Frey (Ross), trumpet; Robert McKnight, bass horn; Percy McGhee; Bob Bender, saxophone; and Carleton Phillippi, clarinet.

Claire never forgot the concert near the Fourth of July one year when she and her husband-to-be, Edmund, sat listening to the band in his father's 1921 black Dodge touring car, a large open automobile with a folding top.

The kids had fireworks that night, and someone threw a firecracker into the back seat of the Dodge. "Edmund really scrambled around after that firecracker to save his father's car," she recalled.

The activity in one of the other cars may have been less exciting, but its fruits were just as worthy. Grandma Ottinger brought along her gooseberries and enlisted the entire family in picking out stems as they enjoyed the rousing marches of John Philip Sousa and an occasional overture.

Children played on the grass and young couples strolled about town or stopped for a cherry Coke at the drugstore across the street.

The focal point of the park from the early 1920s until the mid-'30s, the square bandstand housed picnic tables between concerts and was a popular spot for lunch. Occasionally a small reunion was held in the structure.

But the bandstand did not finish its days in the park. In fact, it came to a rather inglorious end. Bert Mills, who owned land where Eagleview Court later stood, raised pigs with his friend Bert Moore. The bandstand was moved to the Mills property, where the latticework at the base was removed and the hogs enjoyed a respite from the sun underneath the deck. You might say it became "hog heaven."

INTERURBAN COMPETES WITH TRAIN

INTERURBAN SPARKED REMINISCENCES OF FIRST TRAIN'S ARRIVAL IN ZIONSVILLE

In the summer of 1903, the people of Zionsville anticipated the arrival of the first interurban car on the tracks recently laid in the center of the town's main street. At that time, much conversation centered on another first in rail transportation: the train.

That auspicious event took place more than fifty years earlier, when Zionsville was little more than a gleam in the eye of its developers. *Zionsville Times* editor Calton Gault recounted the stories of those who recalled the event of July 4, 1852, in the September 17, 1903 edition of his paper.

> *This past week, while people have been sitting around waiting for the first trolley car, has been conducive to story telling of early days of the town and country.*
>
> *David H. Almond recalls that the first train on the Indianapolis & Lafayette railroad (now the Big Four) arrived at what is now Zionsville on the fourth day of July 1852. The road was completed no further than this place, the bridge over Eagle Creek not being finished.*
>
> *The day was celebrated by a Sunday school picnic, and a few of the people came down on the train, made up of flat cars, from the west.*
>
> *Zionsville was not here then, the first house being in course of construction and owned by Uncle John Miller. The house still stands, west of the railroad on Center street, across the tracks from C.L. Gartman's harness shop.*

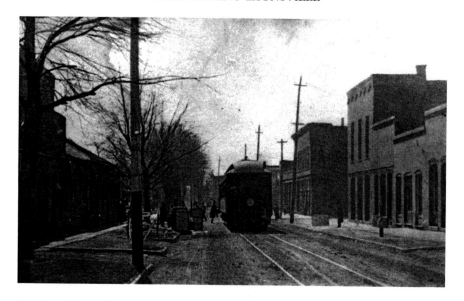

The interurban track was laid along the center of Main Street in 1903. It offered more frequent, faster transport to Indianapolis or Lebanon, the county seat, than did the train. *Courtesy of the Sullivan Museum.*

> *It is told that Nelson Duzan, a practicing physician of that day, remarked that the railroad would never pay, as a man with an ox-team could haul all the freight between Indianapolis and Lafayette there would ever be to haul. The road was completed through to Indianapolis later in the same year.*
>
> *Thomas Speer was present at Indianapolis when the first train of cars came into that town on the old I., M. & I. Railroad. Greensbury Daubenspeck was there the next day.*
>
> *George Reveal helped to grade the railroad south of this place, being quite a good size boy at that time.*
>
> *Many others remember incidents regarding the building of the first railroad and none of them at the time expected to ever see another road built to parallel that line. What will be here in another half century would be a hard matter to predict.*

Gault was right. Change in modes of transportation continued: first the automobile, and then the bus, which replaced rail transportation in downtown Zionsville—but in fewer than fifty years.

Today, though, let's begin to explore that period of time from anticipation to arrival of the interurban, which Gault originally referred to as the "trolley."

Interurban Competes with Train

In an article on October 31, 1901, he reports:

Zionsville again has two prospects for a trolley line, or a prospect for two trolley lines. In addition to the Lebanon company, which is again in a state of activity, a company has been organized at Frankfort with the avowed purpose of building a line to Indianapolis by way of Kirklin and the Michigan road.

The Lebanon company held a meeting at Whitestown one night last week in which the promoter stated that all they asked was a private right-of-way just outside the highway, and this seemed to strike the people as a favorable proposition and the work of securing the privilege is now going on.

This company claims that it has the necessary money promised as soon as the right-of-way is secured and that work will commence at once thereafter. Our people are willing to extend the glad hand to either company or both of them, and the one that gets here first will be the best.

Under the headline "Traction Deal Closed," Gault reported on December 25, 1902, that "the Indianapolis & Northwestern Traction Company is now one of the big corporations of the State."

He continued:

It was incorporated last February as the Indianapolis, Lebanon & Frankfort Traction Company with $25,000 capital stock. Yesterday it notified the Secretary of State that its name had been changed to the Indianapolis & Northwestern and that its capital stock was increased to $2,500,000 with the privilege of increasing this to $3,000,000 by additional common or preferred stock.

The firm, Gault reported, would be popularly known as the Lebanon, Crawfordsville and Lafayette line. It was currently under construction between Frankfort and Zionsville. He also listed the schedule of completion for the various branches of the line, stating that the Zionsville to Frankfort branch was to be in operation by July 1, the Crawfordsville branch by September 1 and "by Dec. 1, a citizen of Indianapolis will be able to travel in a limited palace car from here to Lafayette. Failure to establish service on the dates named involve heavy penalty."

"Zionsville Was a Wonderful Place to Grow Up"

Thelma Shelburne Dye was thirteen in 1911, the year the brick main street was laid in Zionsville. Being a girl, she did not have much interest in the actual preparation for and laying of the bricks, but she remembers that townspeople were not all in agreement on the project.

"I know there was a lot of controversy over whether to spend the money," she says. "Some were for and some were against it because it was a costly project. I remember all the work that went on, and the piles of brick down the street."

Thelma and her brother, Manfred Shelburne, visiting from his California home, recalled the Zionsville of their youth during a 1987 interview in her Lebanon apartment. They both had vivid memories of the interurban line that served the community as it passed through town on the way to Lafayette or Indianapolis.

Riding the interurban to school from the Shelburne home on Pleasant View Church Road as a first grader, Thelma was placed in the care of the

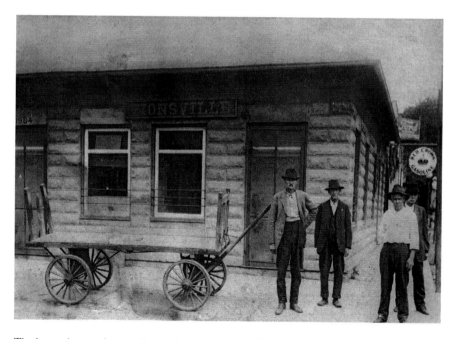

The interurban station, on the northeast corner of Main and Cedar, was built in 1904. It was constructed of huge cement blocks (thirty-two inches long, one hundred pounds) made locally. *Courtesy of the Sullivan Museum.*

conductor, George Lewis, by her father. Lewis, she recalled, was the brother of her teacher.

Later, as a ten- or twelve-year-old, her parents sent her by interurban to Indianapolis, where she went to the office of "Uncle Doctor" (William P. Shelburne, an eye, ear, nose and throat specialist), who had previously had a general practice in Zionsville.

Then, as a freshman at Purdue University, she again boarded the interurban for occasional trips between home and school. Although the distance seems short today, Manford said, "Lafayette seemed far away then."

Manford himself, twelve years Thelma's junior, recalled commuting to Indianapolis by interurban while he studied at the Metropolitan School of Music. He agreed with the assessment that "interurban service to Indianapolis was certainly a wonderful thing," adding, "They were nice cars, too—very comfortable cars—and so reliable."

One of the reasons Lafayette, and other communities, seemed so far away when the Shelburnes were young was that there were no radios or televisions to instantly relay information from one community to another.

Their Uncle El Hill, who owned a hardware store where the Thomas Kinkade Gallery is now, lived with his family in a house across the street (where Heritage Realty now stands). On election night, Leander and Nellie Shelburne and their children would go to "Aunt Meddie's house and Dad and Uncle El would go up and down the street wherever they had election news" to learn how the Democratic candidates they favored were faring. Then they would take the news back to their waiting families.

But Zionsville was not the only town where news was hard to come by. "I was in Purdue that first year in wartime," Thelma recalls. "I lived on Andrews Street in the Alpha Chi house, and we knew that the Big Bertha was headed to Paris. Every hour two girls from the house would go up to the village, where the news came in by telegraph, to find out if the Big Bertha was shelling Paris."

Thelma had been a fan of the Five-Hundred-Mile Race ever since the days when, as a small child, she rode in the horse and buggy with her parents, east to U.S. 421, where they would sit and watch the cars going to the race. "There weren't any cars in Zionsville then," she says, "but there were automobiles in Chicago. The people from Chicago would come down 421 in their automobiles on their way to the race."

A few years later, when the Shelburnes lived on Willow Road, Thelma ordinarily rode to school with some high school girls in a horse and buggy.

One spring, when Eagle Creek was overflowing its banks, she recalls, "Dad took me to school on horseback. I must not miss a day of school."

As a beginning teacher in 1918, Thelma found herself in charge of the eight grades at Buzzard's Roost. "I didn't want to teach grade school," confesses the lady who taught high school English and home economics, but Walter Pitzer, who was Eagle Township trustee, didn't have a teacher for Buzzard's Roost and school was about to open. "He talked to my father, who promised, 'Thelma will be there on Monday morning.'"

Although the position was supposed to be temporary, she remained the entire year, and credits her successful survival to T.H. Stonecipher, Zionsville's principal, who "helped me get through that year."

A particularly memorable experience at Buzzard's Roost occurred one day while the children were out on the playground. "We were on the playground at Buzzard's Roost in November," Thelma said, "when we heard bells ringing and guns firing in the distance, and we knew the war was over."

CHAPTER SEVEN

SIGHTSEERS DRAWN TO OCTAGON HOUSE, TRANSIENTS TO TURLEY HOTEL

LIFE IN THE OCTAGON HOUSE IS REMEMBERED BY TWO

When two Zionsville residents meet, the conversation often drifts to anecdotes of life in the Octagon House, where both lived during their youth, one after the other. The house, built on a rise north of town in the mid- to late 1800s by banker Philander Anderson, was one of only a few thousand homes of this very rare style that enjoyed some popularity at that time in New York, Massachusetts and the Midwest.

Jess Brinley Bower, who called it "the round house," moved there in the fall of 1913 when her parents, Grover S. and Eva Conrad Brinley, acquired the property and a house on Maple Street in a trade with W.S. Rooker for what later became the Ford farm on Ford Road.

"It wasn't a very livable house," reported Mrs. Bower, who lived there when she was in the second and third grades in school. Its eight sides dictated that all rooms were pie shaped, so there was a problem making rugs fit. "Mom folded them under," she recalled.

Zionsville physician Dr. Lawrence Bailey also remembered a problem with rugs. "They were either folded under or they ran up the wall," he said.

Dr. Bailey and his mother, Lulu Isenhour Bailey, moved into the house when he was twelve years old, with his widowed grandfather, John Isenhour, who purchased the property on eleven acres of land from the Brinleys.

"The three-story house sat on a hillside and you came up the front walk to the second floor," Dr. Bailey recalled. "The doors to the basement opened on ground level at the back. There was a summer kitchen in the basement,

Built by banker Philander Anderson for his wife, circa 1880, the uncommon design of the Octagon House made it a tourist attraction—and a challenge to carpet. *Courtesy of the Sullivan Museum.*

Sightseers Drawn to Octagon House

and a winter kitchen and the dining room on the second floor. A dumb waiter carried food between floors."

Both former residents remembered the water tank on the third floor that provided running water by gravity. "When we lived there a family named Hogan pumped the water into the tank for us," Mrs. Bower said, and they mowed the spacious lawn.

An electric pump had been installed in the interim, so Dr. Bailey did no pumping, but he vividly remembered mowing the lawn, one of his chores, along with milking two or three cows, washing the multitude of windows and making pies and cakes.

Mrs. Bower attested that he did indeed mow the lawn, since he came to mow before they had moved out. "I hollered out the window [to him] and said, 'I'm glad I don't have to do that!'"

"Mom had enough furniture to furnish every room but one where the trunks were stored," she noted. "My friend, Kathleen Swaim, liked to stay all night with me because I had a room of my own and because I told her the room with the trunks was haunted."

When it was time to leave the house, she resisted because she had been told that in the country she would have to walk a long way to school and she had been warned not to accept rides with strangers. Trying to avoid the inevitable, the frightened little girl hid in the dumbwaiter.

According to his grandson, John Isenhour was a "self-made botanist" who planted and experimented with cherry, peach and apple orchards and gooseberry and currant bushes and sold their fruit from the property.

Because of the elevated site of the house, "we got all the wind," the doctor recalled, and the house was very hard to heat. "When the wind came from the north or northwest, we stayed on the south side of the house. The furnace didn't heat the third floor very well, so you undressed by the stove and ran upstairs to get to bed."

Isenhour died in 1940, and his second wife, Mittie, occupied the house until her death in 1950, when the property was given to Dr. Bailey, who had kept up the taxes for his step-grandmother.

"I had been in the navy for about six years, and when I came back I had a feeling that many of the others coming back from the service didn't have a place to live. I felt sorry for them, so I decided to subdivide. Besides, the house was badly in need of repair."

The Octagon House was razed, its site became the turnaround in Bailey Court and the lovely rolling acreage behind it became Isenhour Hills subdivision.

Sightseers Drawn to Octagon House

Zionsville's Turley Hotel Overflowed in the 1930s

When Lawrence and Edith Turley bought the Hiland Hotel in 1935 from Edith's aunt, Rose Hiland, and her husband, William C., they bought a bonanza.

In the next five years, three major employers in the area—Shell, Panhandle Eastern and Rock Island—would build and staff facilities near Zionsville, bringing to town many bachelors, or temporary bachelors, who needed a place to sleep and a home-cooked meal at least once a day.

Renamed for its new owners, the Turley Hotel was the only hotel within miles. Indianapolis, with its border directly to the south, not far beyond 38th Street, was connected mostly by gravel roads.

Along with a hotel full to overflowing with guests, Edith Byrket Turley acquired a massive job in the days when laundry and cooking were done the hard way. With the help of her two sons, Max, a teenager when the hotel was acquired, and Meredith, three years his junior, she changed beds, washed sheets in a hand-cranked basement washer, hung them on the line to dry and pressed them.

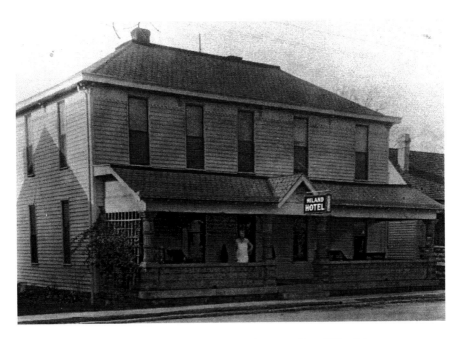

When Edith Turley bought the Hiland Hotel from her aunt, Rose Hiland, it was an overnight success because of the temporary bachelors drawn by jobs with Shell, Panhandle Eastern and Rock Island. *Courtesy of Meredith Turley.*

Lawrence Turley worked at the post office in Indianapolis, from which he later retired as head of the Manpower Commission.

Meredith recalled what a help it was when his mother bought a mangle that pressed the sheets. Another labor saver that was "like something from heaven" was the stoker that fed coal into the furnace, relieving the boys from the backbreaking job of hand shoveling.

To keep fresh bed linens on hand, the boys would sometimes do laundry while they were home from school for lunch.

During warm weather, the hotel was so crowded that cots were set up in the hall, on the front porch, in the basement and even in the backyard under the pear tree. Mosquito netting draped over the clothesline made backyard sleeping more comfortable.

A bed cost three dollars per week and dinner was fifty cents a meal. Served family style, the meal always included at least two pieces of meat per person (two pork chops, two cubed steaks, etc.), Meredith recalled. After a hard day's work, the men were really hungry, he said. "They'd eat like hogs."

Playing a little poker helped pass the evenings in town, where everything but the tavern closed early.

Typical of a boardinghouse, the long table always managed to seat every man who had told Mrs. Turley in advance that he would be there for dinner. Not all of the guests ate at the hotel every night; sometimes they would go to Arnol's Cafe, just down the street.

After Shell and Panhandle were in operation, some of the superintendents would stay at the Turley Hotel with their wives and families until they found a permanent place to live.

Of the scores of men who found rest at Turley's, Meredith still recalled some by name at the time of this interview. Roommates who worked for Panhandle were a man whose surname was Batman and one whose first name was Robert. They easily became Batman and Robin in the days when the cartoon of the same name was a popular seller on the newsstands. Another man was called "Walker" because he was employed as an inspector by Panhandle, walking the pipeline to spot leaks. Walker knew that Mrs. Turley would always save a bed for him when he was walking in this area, every week or two.

All was not work for the Turley boys. They played their share of practical jokes and took part in their share of boys-will-be-boys shenanigans in their free time.

Sightseers Drawn to Octagon House

After they were grown, married and had moved into their own homes, hotel life was not so hectic in Zionsville. In fact, by the late '50s, there was so little transient trade that Edith Turley converted her hotel into six apartments.

YOUTHS FOUND FUN EVERYWHERE, ANY SEASON

ONE HUNDRED YEARS AGO, TEN-YEAR-OLDS PLAYED COPS AND ROBBERS IN REAL JAIL

They were never bored—Hot Times, China, Brom Bones and Dick. When they weren't shooting marbles, they were playing hockey with an old tin can. Or they made darts from old wooden shingles and launched them with a string on a stick to see how far they would go. Of course they all had their chores at home, but there were plenty of hours left for a good time. They didn't need much equipment to keep them happy—just a pouch filled with marbles. Most everything else was improvised.

When they were a little older, they'd be allowed to go out after dark for a game of hare and hounds. Sometimes, now, as they lay in bed, they could hear their older friends call out: "Whistle or holler, the dogs can't foller."

But for now, like all ten-year-old boys, one of their favorite pastimes was a rip-roarin' game of cops and robbers. And here they had an edge—the cops could throw the robbers into an honest-to-goodness jail, even though they marched them there at gunpoint with weapons fashioned from sticks.

Down on Water Street (now Elm), near the south end of town, stood the small frame building that was Zionsville's jail. It was old and dilapidated, but it still had iron bars on the door and on the two small windows. The boys had never seen a prisoner locked up there, but they'd heard that sometimes Marshal Bill White let a transient sleep in the jail overnight so he'd have a roof over his head.

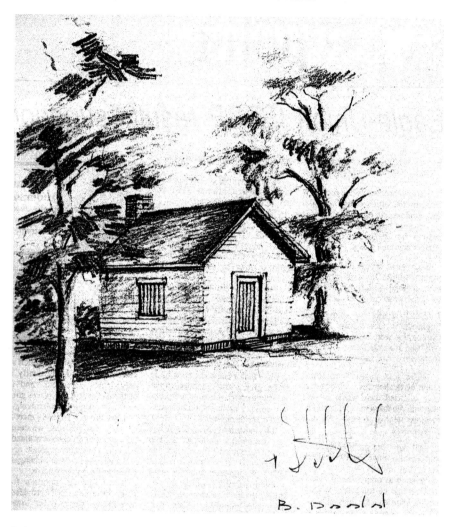

In Paul Way's childhood, the town jail never housed any real criminals, just transients needing overnight shelter. Never locked, it was a great place to play cops and robbers. His memory was captured on paper by grandson Bret Dodd. *Courtesy of Paul Way.*

There'd never been much crime in town, and anything really bad would probably be dealt with in Lebanon, the county seat. But Zionsville had a justice of the peace—Judge Stubbs, who lived right at the north end of the main street—and he could throw somebody in the local jail for disturbing the peace.

The structure was just big enough to hold a cot, a pot-bellied stove and a chair with a small table for the prisoner's meals. Marshal White never fed the transients, but a real prisoner would have to have regular meals.

The jail was never locked when it was empty, so the boys were free to go in and out as they pleased. And they could sentence their "robbers" to serve their sentence there for as long as they wanted—so long as they all got home in time for supper.

OF SLEDDING AND SLEIGHING AND SKATING ON SNOW

Snow on the ground all winter—that's what Irene Smith Markland remembers from her childhood in the early twentieth century. Consequently, sledding was a very popular sport in Zionsville.

Proper young ladies, of course, didn't wear pants, not even snowsuits, but they did wear layers of garments that kept them warm, and their sleds were modified to keep them in a lady-like position while sledding. First came long underwear, then heavy, long stockings covered by a petticoat and a heavy woolen skirt and sweater. Over their shoes they wore galoshes, which were heavy boots closed with metal buckles. Other outer garments were full-length coats, hoods, knitted woolen gloves with long tops and mufflers.

Sleds for girls were built with a seat, providing a low back rest (and preventing the rider from even considering using the sled to do belly-flops). Carpenter Paul Way built sleds for his children, when they were small, with a box on top for them to sit in so they couldn't slide off.

The founding fathers of Zionsville must have had sledding in mind when they laid out the streets of town, because children could slide all the way from Walnut Hill, where the school stood, straight down as far as the railroad tracks on what is now First Street. And they did so at recess and after school. Another good spot for sledding was Pine Street, where traffic would be barred expressly for the children to slide.

"We used to have a lot of snow," Irene recalled, "with the first snowfall coming in November or December. There would be snow on the ground continuously until March or April. One snow, sometime in the '20s after I was married, fell the first week of May."

The year her youngest daughter was in the first or second grade, the snow was so deep that her middle daughter and a friend carried the little girl through the snow to school.

The Smiths had a sleigh, pulled by their horse, Prince, which provided great winter transportation, even as far as Noblesville, where they went to visit Irene's grandparents. For the long trip, her father heated bricks, wrapped

them in newspaper and stowed them on the floor of the sleigh to keep their feet warm. Of course, they always took along plenty of woolen lap robes. Prince wore musical sleigh bells on a chain that snapped around his neck.

One time, when Irene and her father were riding north on Main Street in the sleigh, a runner caught on the interurban track. "We went over," she remembered, "and all our blankets fell out. But we just laughed."

Paul Way noted that snow was removed from sidewalks and streets far differently than it is today. "We used to have pretty nice sidewalks," he said. "You could roller skate around town." To remove the snow from all those sidewalks, the town hired Ben Davidson, a drayman, who harnessed one of his horses to a special triangular scraper he had made to push the snow off to each side of the sidewalk.

Aub Davidson remembers well his father's self-designed snowplow. "It was about four or five feet wide at the back," he says, "and about five or six feet long, made of wood, with upright boards on each side. He stood on the back end and harnessed Maude to a singletree with a short chain so that she was three or four feet ahead of the plow. If he hit a rock or a curb, he would go one way and the snow would go the other."

Maude, Aub said, was "the prettiest horse in town and she could out-pull any team of horses in Boone County."

The town also hired someone to clean the streets of snow with a road grader pulled by two horses. The blade could be turned either way to throw the snow to one side or the other.

One-room schoolhouses were often closed two or three days at a time while the county cleared the roads, but schools in town were closed only if it was very, very cold or slick. "Snow didn't bother," Paul recalled. "There was a snow around 1928 or '29 that was so deep it covered the fences. It was followed by a short warm spell when it rained a little, and an immediate deep freeze so that there was an icy crust over the snow. We could ice skate all over the country, right over the fences."

COTTON CRUSE SEARCHES FOR A PORCH STRETCHER

Nobody ever said that big boys are always considerate of little boys' feelings. Nor has anybody said that big boys pass along their worldly knowledge in a gentle, kindly manner. Actually, the reverse is usually true. The innocents who look up to them and "can't wait" to be old enough to do just what

they do are often embarrassed, ridiculed and made the butt of jokes at the hands of their heroes. This is not all bad. In fact, it may be just what the Creator intended.

What better way to learn caution and worldly wisdom, and develop a healthy suspicion, than at the hands of those who would be the first to jump to their defense if they were really in trouble? It is impossible to avoid all the pitfalls of adult life, and the young must somehow be made aware that they are there.

"Cotton" Cruse was about five or six years old on a particular summer day many years ago when rain spoiled the tennis match being played by Alvin Hussey and Leslie DeVoe on the Gregory tennis court. The boys reluctantly retired to the nearby Hussey front porch to wait out the shower. What followed went something like this:

Cotton was nearby, as he usually was when his heroes were anywhere in sight, and they decided to test his gullibility.

"Wouldn't it be great if we could play tennis right here on the porch?" one said. To which the other responded, "We could if we only had a porch stretcher. Then we could make the porch big enough for a tennis game. Say, Cotton, how about going down to the lumber yard to get us a porch stretcher?"

The little boy obligingly trotted off, only to be told at the lumberyard, "Sorry, we don't have any. Why don't you try the hardware?"

So he headed cheerfully up Main Street to the hardware store. Once again, he was told, "Sorry, we don't have any. Try Swiggett's by the railway depot." And this time he hit the end of the line in his search. "Young fella, there is no such thing as a porch stretcher. You just can't stretch a porch."

Charles Roland Cruse laughed about the incident as he recalled it and admitted that he had many other memories of his growing years in Zionsville. One of those memories was from his early teens when he and his cousin, Max Ottinger, ran a trap line on the Johns' property northeast of town. The boys would ride their bikes or walk out there as early as 4:00 a.m. to see what was in their traps.

They would sell the animals they caught without skinning them. A muskrat brought $1.25, a rabbit $0.25 and a mink $3.00 or $4.00.

After emptying the traps, the boys would return to town in time for school. One day, however, they weren't permitted to stay in the classroom very long. It seems a skunk had been caught in one of their traps and the boys hadn't handled it properly when they removed it.

Bicycle rides or races were always popular in this quiet community where the cyclists faced much less traffic than they would today. *Courtesy of Meredith Smith.*

Baseball games were a popular pastime in those days, with an ongoing rivalry flourishing between the country boys and the city boys. The former were known as the "Country Hayseeds," and the latter as the "City Straws."

Known around town by his middle name, Roland, as well as his nickname, Cruse explained that Cotton was a shortened version of Cotton Top, given him in recognition of his towhead. Later, after he sang a song in an operetta that had the words "Skinamarinky dink" in the chorus, he was dubbed "Skin." Only after he enrolled at Butler University did he become Charles.

"We Had a Lot of Fun"

Eagle Creek was a big attraction for Zionsville youth when Leonard Grizzle was a boy. "We used to spend lots of time there," he recalls, swimming,

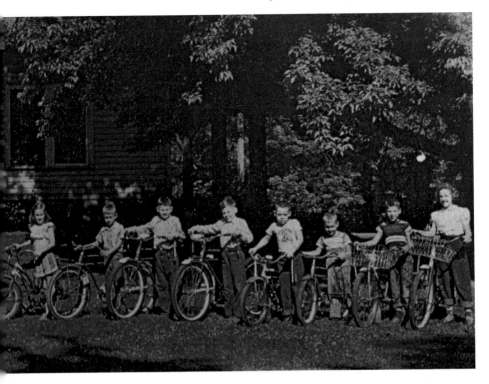

diving off the abutment, building rafts to float down the creek, digging caves in the cliffs or just fishing.

"I wanted to go swimming with my brother and his friends," Grizz remembers, "and they said, 'If you're going swimming, you're going to have to learn how to swim.' Lessons were given very abruptly in those days. They'd just pick you up and throw you in and you'd swim or sink. Somehow you always managed to swim."

Woody Delong, who had a service station, let the boys use a large truck inner tube he had. "We'd use it to play games like King of the Mountain," Grizz says. "We had a lot of fun with that."

Fishing was good, with sunfish, bass, crappies, suckers and crawdads aplenty.

In the late '30s and '40s, Eagle Creek was deeper than it is today. Water fun centered on the area between the bridge over the creek on Zionsville Road and State Road 334.

But the youth of that day found lots of things to do anywhere and everywhere in town. Some could be listed in the harmless prank category,

like placing a billfold or purse on the sidewalk where it would be seen and then hiding back in the alley until someone came along and stopped to pick it up. A yank on the string attached to the treasure would leave the startled passerby blushing and the perpetrator chuckling.

Another prank was regularly played on a certain schoolteacher who had a habit of stopping at the drugstore each afternoon on her way home from school. She would leave her car parked in front, and while she was out of sight, the boys would sneak up and stuff a corncob with a potato on the end into the exhaust pipe. When she returned, "She'd grind on the car until it would shoot the corncob out," Leonard recalls. "It would make a lot of noise and smoke would roll."

A neighborhood boozer was another target of the youthful humor. He raised ducks and always pushed a wheelbarrow downtown to haul garbage back from the grocery to feed them. When he was due to pass along a certain street, the boys would lay a row of walnuts across the road to see if, with his unsteady gait, he and his wheelbarrow could pass between the nuts.

In the "cry wolf" category comes the prank that involved lying in a ditch beside the road and moaning and groaning when a car passed by. If the kindhearted motorist stopped to ask what was the matter, the response would be, "Nothin'. I'm just layin' here restin'."

About the time Leonard was thirteen or fourteen years old, soapbox derbies were the rage. Zionsville youths wanted to participate, too, but they didn't have a lot of money to spend on their cars, so they held their own version of the derby on Ash Street, from Fifth to Main.

"We changed the rules a little," says Grizz. "We used any kind of wheels we could get ahold of. I, personally, used baby buggy wheels." Some of the others used bicycle wheels or roller skate wheels—anything they could find.

Grizz's green car was made of a couple or three boards nailed together, with a rope for steering, and wood across the back. "Real fancy," he laughs. "It was like a pushmobile. It had a seat, something you could lean back on," and the power came from a friend who gave a push to the back end of the car with a stick. The car that could go down the hill the fastest, won. Grizz took home the fifteen-dollar prize donated by State Trooper Scofield.

But all was not fun and games for the youngsters. Some worked, and all had chores at home. Grizz went to work at the Southside Market when he was twelve. He swept, stocked, carried groceries and (after he could drive) delivered, learning many lessons that have stuck with him, but none more so than the time he was sacking chocolate drops for a big Christmas sale.

Youths Found Fun Everywhere, Any Season

The village pump, complete with tin cup, stood on a prominent street corner, handy to thirsty youngsters. *Courtesy of Meredith Smith.*

I liked chocolate drop candy real well, and as I was bagging it my boss, Cap Shepard, caught me. I was eating about two out of three, I think, and he said, "You just go ahead and eat all you want."

I just ate all I could the first day. The next day I had to do the same thing and, believe me, today I really don't care for chocolate drop candy.

CLASSES WERE IMPORTANT, BUT SO WERE SPORTS

VILLAGE STREETS BECAME CLASSROOM IN 1923–24

There was no mechanical drawing class at Zionsville High School prior to the 1923–24 school year. But with five boys in his manual training classes interested in the subject, George Eckerly thought he could make it happen, despite insufficient classroom space and equipment.

The boys would have to pay for their own equipment. They would need tools that could be found no closer than a specialty store at Indianapolis, H. Lieber, which sold art and drafting supplies. Eckerly himself would make the trip to the city to select what they each needed: a drafting board, T-square, compass, triangle, ruler, basswood engineering ruler (for scale drawings), pencils and inking pens. Their classroom would be the stage in the assembly room and the village streets, and the class project would be a scale drawing of those streets.

The boys who availed themselves of this special opportunity were Lorenz Bower, Stanley DeLong, Mark Hull and Harvey McLaughlin, all seniors; and Mark's younger brother, Forrest, a junior.

Mark was assigned to shoot the angles with a makeshift transit, while the other seniors paced off the distance. To make the pacing as accurate a figure as possible, each boy's stride was measured, and that dimension had to be taken into account in calculations. Forrest was given the job of compiling the data collected and making the final drawing, using a larger drafting board provided by the school.

Street Scene, Zionsville, Ind.

This postcard photo of Pine Street illustrates why it was fortunate that members of the first mechanical drawing class at Zionsville High School didn't have to concern themselves with topography. *Courtesy of the Sullivan Museum.*

Village streets, at that time, were not the paved thoroughfares we have today. Rather, they were topped with gravel, a vast improvement over the mud that was its precursor.

Mark's wife, the former Elizabeth Smith, also a senior that year, vividly recalled those dusty roads, for they had given her a city-type diversion when she visited her grandparents, Howard and Elizabeth Todd, at the southwest corner of what is now Fifth and Cedar Streets. The young girl, whose farm home was southwest of town on what is now Hunt Club Road, was accustomed to well water, so the running water in town was a treat in itself. And she dearly loved turning the hose on the streets along the side and front of the Todd home, using the valid excuse that she was "laying the dust" stirred up by the buggies that regularly passed.

Since the boys could make their survey only on dry days, when it was not too cold or windy, it took the entire school year to complete the mechanical drawing project. When complete, their work was turned over to Editor Cal Gault at the *Times* office, who secured a blueprint (probably at Lieber's), and they knew the satisfaction of a job well done. But they were really proud when Metzger Lumber Company posted their blueprint in the store, where it remained for many years.

Besides, it had been quite a lark to be able to leave school for an hour or more during good weather, Mark recalled.

Since the town had not been mapped for some years, their layout of the streets proved to be a useful contribution to the community, and their class, the first ever in mechanical drawing, became a model for those that eventually followed.

The town renamed many of the streets in an ordinance adopted on November 11, 1935. The changes resulted from a successful campaign by the Lions Club to bring home delivery of mail to the town. Since this required the installation of street signs, the time was right to make any changes.

The logical plan that was developed gave all north and south streets west of the main street, appropriately renamed Main Street, a number. All east and west streets were given the names of trees. The only exception to this well-thought-out plan occurred east of Main Street, where two north–south streets bear the names of trees.

SPELLING BEES BROADENED TO STATE COMPETITION IN 1910

"You have noticed in the daily papers of the state a movement to improve the spelling of pupils in the grades."

Sound familiar? Yes, those words might well appear in any community paper in Indiana, or any other state in the United States. And the key word might be spelling or mathematics or science or reading or any of the other basics of a quality education.

The point is, although the above words were taken from the *Zionsville Times* edition of December 22, 1910, they could have come from any contemporary newspaper of that time. Because unless the importance of education is continually emphasized in homes, communities and states through the media, attention lags and the demand for quality slips. To improve lagging skills in spelling in 1910, a series of spelling bees was proposed, as the "School Notes" column reports:

> *Every school in the state has selected three spellers to compete in their respective townships. The three best spellers of the township will compete in a county contest. In turn, the best spellers of the county will compete in the district and those of the district in the state.*

The aim is to create a wider interest in and to improve spelling. That this is needed we can all see, but like everything of that kind, much depends upon the co-operation of school patrons.

The contest for this township will be held Friday night at the Town Hall. We hope every school patron in the township will be present. No admission will be charged. After the children are through, we hope those present will join in an old-fashioned spelling bee.

The following pupils will take part in the spelling bee contest Friday night: District No. 2, Laura Tudor, teacher; Mark Higgins, Howard Jervis and Vern Moore. District No. 6, Mabel Gregory teacher; Harold Smith, Leona Stum and Alfa Lane.

District No. 5, Pirtel Shaw, teacher; Buena Marsh, Amanda Klinger and Rosa Wood. District No. 9, Bert Moore, teacher; Retus Hull, Inez Cooper, and Winthrop Phillips. District 7, Emma Moos, teacher; Barclay Shaw, Eddie Thompson and Bena Moos.

District No. 1, 7th and 8th grades, Charles Crawford, teacher; Mary Shelley, Marian Palmer and Sybil Stonecipher; second, Inez Cooper; third, Mary Edna Shelley; fourth, Effie Thompson; fifth, Sybil Stonecipher.

Those getting first, second and third places will represent Eagle Township in the county contest which will be held sometime in January. Those getting fourth and fifth places are alternates.

On January 26 came this announcement in the column: "The spelling contest went against us. We have no apology to offer. Our pupils made a very good showing. Inez Cooper was the 28th pupil to retire, leaving 14 on the floor. We hope to win next year."

There was no follow-up comment as to whether the adults held a spelling bee, as suggested, after the original township spelldown. Perhaps they were not anxious to chance it in front of the students. I know that I would be reluctant today. Even though spelling was my best subject in the grades, I would be hard pressed to compete when it came to the vast number of technical words that have been added to the dictionary since those days.

HUSSEY BEQUEST GIVES LIBRARY ITS OWN BUILDING

The Pitzer Library, as the Eagle Township Library was commonly called, served Zionsville for more than sixty years, from 1898 to 1962. At that time,

thanks to another bequest much larger than the $600 given by Joseph B. Pitzer, the Town of Zionsville received property designated specifically for use as a public library, and a trust fund to help with its maintenance.

Before we move on, let's take one last look behind the scene at the Pitzer Library that, during its sixty-year existence, changed location whenever the township trustee moved. You see, as the Eagle Township Library, it was the trustee's responsibility. Sometimes it was located on Main Street; at other times it was in the school (also administered by the trustee).

One move is still very vivid in the memories of Aletha Phillippi and June Becker. It was sometime in the late 1950s, when Farmers State Bank expanded to the north into a storefront occupied by the trustee and the library. Both moved next door, into space on the second floor of the Bender Building.

Aletha was the wife of township trustee Carleton Phillippi and June was a member of the township library board. To them fell the task of helping to carry all the library books upstairs and organizing them properly on the shelves.

What really impressed the ladies, though, was the way the trustee's heavy safe reached the second floor. They, and many other townspeople, stood in awe as Gene Pock brought his crane onto Main Street and lifted that safe through a second-story window.

Now, back to the Hussey family gift: Lora Hussey, a former schoolteacher, died April 17, 1957. She was the only child of Milton and Ella Hoffman Hussey. Her gift to the town of more than $200,000 in assets was the fruition of a dream that she and her parents had cherished and planned for as a family. Those assets included the family home at 255 West Hawthorne Street, which she designated for use as the Hussey Memorial Public Library.

Although the will was probated in May 1957, it was the summer of 1960 before the estate was settled, because several of Lora's cousins contested the will. Following the settlement, and in compliance with the will, the town trustees appointed a five-member board to assume administrative duties.

Transfer of administration of the estate and creation of the library from the Town Board to the new Library Board was begun on Monday, October 17, 1960. It was a lengthy process because of the nature of an estate that included a 172-acre farm in Hamilton County, appraised at $120,000, the Hussey home and another house and lot at 205 West Hawthorne. Final transfer of administration, by resolution, was made Monday, December 5, 1960.

Members of the first Library Board, named by the town trustees to administer the library, were Esther Shelburne, president; Martha Wharry,

vice-president; Dorothea Renner, secretary; Edward Karraker, treasurer; and Jesse Phillippi, representing the Town Board. The first librarian was Madge Hightshue.

CHEERLEADERS LED STUDENT BODY IN CELEBRATION OF REGIONAL WIN

Basketball hit a new high in Zionsville in the 1952–53 season, when the Eagles brought home the only Regional Tournament championship in school history. This is the story of four students, three girls and one boy, who led fan support during an amazing season.

Apparently the early 1950s was when the designation yell leader was replaced by cheer leader (two words then, one today). The 1953 *Aerie* uses both terms in referring to the squad of four who had been selected by the student body to keep spirits high, both on the playing floor and in the stands.

Cheerleaders, whose enthusiastic support was directed at the only local team to win the Regional Tournament, included Jean Johnson, Betsy Atkinson, Janet Rosenstihl and Marion West. *Courtesy of the Sullivan Museum.*

Classes Were Important, but So Were Sports

Jean Johnson (Hypes), varsity cheerleader in 1950–51, 1951–52 and 1952–53, had returned to Zionsville from Sarasota, Florida, for the final game to be played in the varsity gym when I spoke to her in late February 1998.

Although she and her fellow cheerleaders—Betsy Atkinson, Janet Rosenstihl and Marion West—had never led cheers in that building, she was eager to gather with the four other members of her family who had: her sister, Julia Johnson (Aronson), and her three daughters, Lori, Lynn and Lisa, who followed in her footsteps. Their stories reflect the evolution of cheerleading from the early 1950s to the mid-1970s.

In her sophomore year, Jean and the other female cheerleaders wore a walnut brown corduroy skirt that reached to mid-calf. The circular skirt was lined in forest green, and beneath it she wore brown tights. On her feet were white bobby socks and either tennis shoes or brown saddle oxfords. Her sweater was white, with a green "Z" trimmed in brown. In her junior and senior years, she dressed much the same, except that her skirt was forest green. Marion West, who joined the squad in his senior year, wore brown corduroy pants.

Physical education and history teacher Yolanda Cox was faculty advisor to the four, who practiced in the gym during the one period each day when they had study hall. Yells were more or less exchanged between schools by the yell leaders, who then adapted them to fit their school nickname, colors and the like. Handsprings were not considered appropriate behavior.

Although the last half-hour on Friday afternoons was devoted to a pep session during basketball season, the most memorable one, in Jean's days as cheer leader, took place on the Monday following that regional championship game, when *Indianapolis News* reporter Virginia Ericson was at the scene. Ericson wrote:

> *There was no school in Zionsville today.*
>
> *Principal Charles Franklin would have had to tie the roof down on the school if he'd kept the youngsters in. That's how high the spirit is over the first Regional championship in the history of the town.*
>
> *The heroes of the day are the Zionsville Eagles, who triumphed over Frankfort, 61–56, Saturday, to bring home the victory. And the high school pupils can't cheer them enough. The pupils managed to squirm through their one morning class of the day and then raced to the gymnasium for a pep rally. Even the grade school pupils got to see the rally, although they didn't quite know what to make of the whole thing.*

Cheer Leaders Janet Rosenstihl, Jeanne [sic] Johnson, Betsy Atkinson and Marion West led the school in clapping, jumping, finger-snapping and mostly just plain yelling. Those youngsters really let off steam. A snake dance on the floor of the gym, led by the drummer, Danny Fix, climaxed the cheering and puzzled the grade school youngsters even more.

The members of the team were quiet. This victory was more than they had dared hope for although they worked hard enough to get it. Coach Alfred Rosenstihl first started training these boys to play championship basketball together when they were in the seventh grade.

Player Allen Wharry's mother, Mrs. Foster Wharry, says the boys vowed almost six years ago that they would win the sectional in their senior year. They never bargained on the Regional, she added, and "We're all making the most of it."

Besides Wharry, other senior members of the team that won the regionals were Meredith Abbitt, Robert Carter, Jack Hendryx, Franklin Huff, Frank Nusbaum Jr. and James West. Other team members were Jim Barricks, Gene Marsh and Kenneth Atkinson. The assistant coach was Jim Ruby, and student managers were John Davis and Fenton Carey.

VINTAGE FIRE AND POLICE PROTECTION

BUCKET BRIGADE FOUGHT FIRES IN EARLY ZIONSVILLE

Today when we think of Zionsville's volunteer fire department, we think of those years when well-trained businessmen, shopkeepers and tradesmen left their jobs at the sound of the fire siren to fight any fire in the community. They had the equipment, protective clothing and expertise it took to smother or drown their adversary.

Back in 1921, Zionsville had a volunteer fire department, all right, but it consisted of townspeople who responded to the summons of the telephone operator. They carried buckets and formed a line from the nearest well pump to the site of the fire, along which they passed buckets full of water as rapidly as possible.

This line of firefighters was called the bucket brigade, and more often than not, they bought time and reduced spread, rather than saved a structure. It took a great deal of courage and goodwill to be able to pull oneself out of bed when the alarm came in the middle of the night, but it was part of the neighbor-helping-neighbor spirit for which small towns have always been cherished.

In October 1921, the home of Farmers Bank president James Brendel and his wife, Laura, burned down. Their daughter, Imo Dunn, reconstructs the events of that night.

My mother and father were asleep, but Mama awoke and thought she smelled something unusual. She called Papa, but he thought it was probably

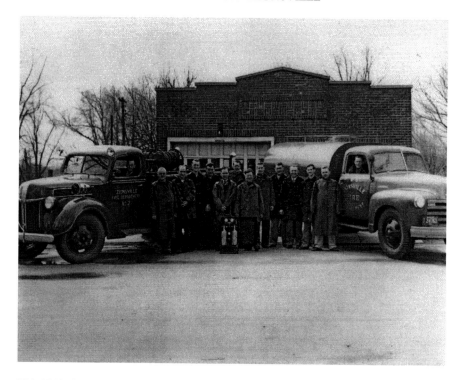

This 1948 photo of the volunteer fire department with its modern equipment includes the firefighter who was also town marshal, Maynard Moore (standing sixth from left). *Courtesy of the Sullivan Museum.*

a gas smell from the railroad [which ran along First Street, a short block from their home at the southwest corner of what is now Oak and Second streets].

They returned to bed, but Mama got up a second time and began to look around. Mama opened the door to one of the upstairs rooms and was greeted by flames. She and Papa hurried downstairs and he yelled to the telephone operator, "Jim's house is on fire!"

Mama and Papa couldn't get back upstairs, so they had only their nightclothes on. Everyone came with their buckets and the men formed a line from Mrs. Barnhill's pump, two doors away.

The ladies helped by carrying anything they could pick up across the street to Mamie Lewis, who took the things into her home. I still have the china that the ladies carried out. Not a piece was broken of the service for twelve. No furniture from the upstairs was saved, but the ladies and some of the men saved the furniture downstairs.

Vintage Fire and Police Protection

The Dunns were living on Fourth Street near Poplar at the time, and Imo recalled several incidents related to the fire. When Frank Dunn arrived, his mother-in-law remembered that she had the Christian church silver in storage. "Oh, Frank, get them," she pleaded, "the church's silver." Someone brought a ladder and Frank climbed up, only to find himself in a precarious spot on bare rafters looking clear down into the basement. But he did save the church silver and Mrs. Brendel's silver, which was packed in old-fashioned laundry baskets.

The heat was so intense, however, that her mother's jewelry and the thick panes of glass in a door were melted, Imo said. The old playroom where she and her sister Fern, both adults at the time of the fire, kept their dolls was completely gutted.

Shortly before the fire, Mrs. Brendel had purchased a new switch (a tress of detached hair, bound at one end and used as part of a coiffure) for her head. It was left upstairs and burned with all else. The fire occurred on Thursday or Friday night, and Imo recalls that her mother boarded the interurban to Indianapolis on Monday to buy a new switch and replace some of her clothing.

After the tragedy, Mr. Brendel related his gratitude that he had had the presence of mind to turn off the spigot to a tank in the backyard that provided fuel for cooking and for lights.

People sometimes react strangely in emergency situations, Imo said. "My father and Mr. Stonecipher, the school principal, found mother sweeping with a broom while the house burned. 'I'm going to keep my furniture and I don't want it to be dirty,'" she explained.

The Brendels moved in with the Dunns after the fire, where they lived until a new house could be built. Although the Indianapolis architect encouraged James Brendel to center the house on the two lots he owned, the bank president was adamant that the new brick structure be at the corner where the first house had stood. "I want to be where I can see the bank," was his explanation.

MAYNARD MOORE: ZIONSVILLE OFFICER AND GENTLEMAN

Affectionately dubbed "Mr. Zionsville" or "Mr. Everything," Maynard Moore had the distinction of being named the first recipient of the Zionsville Jaycees' Distinguished Service Award in 1961. The award might

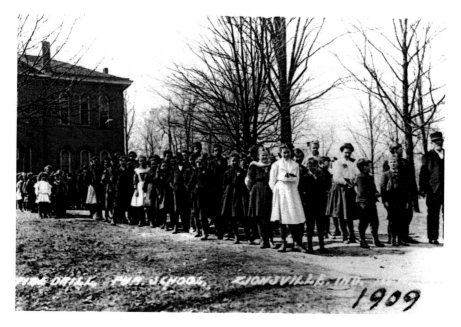

Lined up outside the Academy for a fire drill, circa 1909, is the entire student body of the school. *Courtesy of the Sullivan Museum.*

have been tailor-made, it fit him so well, just like the navy blue uniforms that were made to order for his six-foot frame that never carried more than a trim 165 pounds.

Moore was a civil servant par excellence, in a career that began when he became a charter member of the volunteer fire department in 1930 and continued until his death in 1972. For thirty of those years he was Zionsville town marshal.

Anyone looking for sensational copy would soon give up on Maynard Moore. The gentleman was not even controversial. But maybe that, in itself, is sensational. Anyone who could serve his town as marshal, fire chief, waterworks superintendent, street commissioner and assistant civil defense director without making a few enemies is someone very special indeed.

Harland Pitzer, who worked with Moore as a volunteer fireman, attests: "It's common knowledge that he had no enemies. He just got along with everybody, from the kids to us in the organization he was with."

Claude Robey, his assistant fire chief for several years, clarifies this phenomenon: "He was a very dedicated, loyal man. I enjoyed working with him very much."

Vintage Fire and Police Protection

And he wasn't just pleasant to work *with*, he was also considerate to work *for*, says Leonard Grizzle, who went to work for the street department about 1960 or '61. "He was great. Very easy to work for."

The job Marshal Moore hated most, Grizz says, was having to destroy dogs. At one time people who brought dogs to sell to the Pitman Moore laboratories and had them rejected would turn the animals loose in the community. These strays would then form packs that killed farm animals and were a threat to citizens. The marshal had the responsibility for exterminating them, a job, Grizz says, that "made him physically sick."

Lest the foregoing give the impression that Marshal Moore was a softie, Meredith Smith tells a story that proves otherwise.

Early one morning in the mid-'50s, when we were living at Sixth and Ash, a drunk turned the corner and hit an oak tree, disabling the car he was driving. It seems he had borrowed the car from his brother without permission. Since the car was disabled, he had to use our phone to call his brother. When his brother arrived, a fight broke out and both men drew knives. The drunk picked up a branch and, using it as a club, broke it over the head of the older man. I really thought I was going to witness a murder.

I called Maynard, and when he arrived he just walked in between them and said, "Now boys, that's enough." He had an immediate pacifying effect on them.

Although he earned the commendation of his peers in the Police League of Indiana for capturing, after a one-hundred-mile-per-hour chase, a young man suspected of robbing a bank in Cicero, Moore was probably in the greatest danger of his career while acting as water superintendent.

Since reading meters, preparing bills, repairing leaks and mending equipment were all part of his job in the early days, Moore was inside the town's 100,000-gallon tank, which he had drained in order to repair a broken cable on the drain valve, when he was narrowly missed by a fifteen-pound copper float that fell sixty feet into the standpipe where he was working

Of course, as the town grew, additional full- and part-time personnel were added in the departments he supervised. Streets that had been covered with gravel or mud when he started work were paved with chip and seal.

When he retired, at the age of seventy in 1967, he continued to serve as fire chief, deputy sheriff and weather observer, jobs he held until his death from a heart attack in 1972.

In an editorial written at the time of his death, the *Zionsville Times* aptly noted, in part: "To local youngsters he was a real-life idol. Tall, soft spoken and unassuming, he still managed to convey a quiet heroism. Not until those children grow old and pass away will the memory of Maynard Moore fade..."

LIONS CLUB PROMOTES TOWN, SUPPORTS ACTIVITIES

ADS GIVE INSIGHT INTO LOCAL HISTORY

The Lions Club has been promoting Zionsville, in one way or another, ever since the organization was chartered in 1930. Evidence supporting that statement recently was found in the scrapbook of Bessie Ogborn Smith, longtime local teacher of the first grade. During her tenure of forty-three years, she kept scrapbooks filled with clippings of local interest.

The fact that she clipped the two advertisements placed by the Lions Club in the *Indianapolis Star* in 1931, and considered them worthy of inclusion, speaks volumes about community response to the Lions Club venture.

Zionsville dahlia growers were receiving wide recognition for their superior stock at the time. Tubers from local growers Fred Gresh and Tudor Gardens were sought here and at the Indiana State Fair, where blossoms from the gardens of Gresh and the Tudor sisters were consistently winners of top awards.

Gresh later would receive a gold medal for the outstanding flower of the year from the American Dahlia Society at the 1933 Chicago World's Fair for Zion's Pride, a flower he was developing at the time the advertisements appeared. Little wonder the town was promoted as "The Dahlia City."

It's not known which ad appeared first, or if the two ads were used in the same paper. Mrs. Smith's notation indicates only that this ad appeared in the *Indianapolis Star* in 1931 and that both ads appeared the same year.

One ad was captioned "It's Springtime in Zionsville" over a photo of the Zionsville schoolhouse that, at that time, housed all twelve grades.

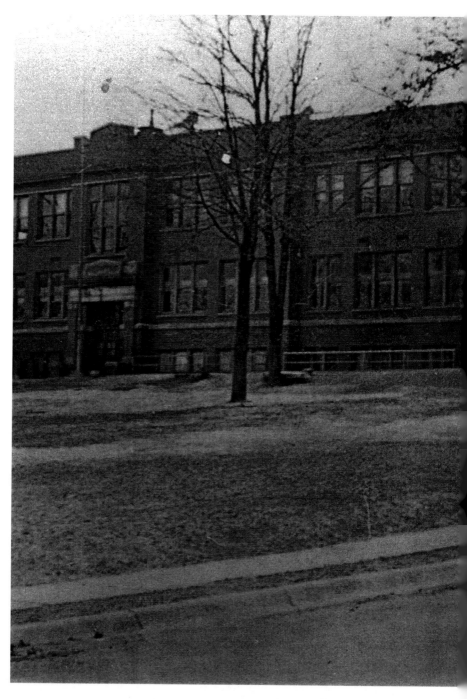

When the Lions Club promoted the community in the *Indianapolis Star*, it included a photograph of the school building that served grades one through twelve. *Courtesy of Meredith Smith.*

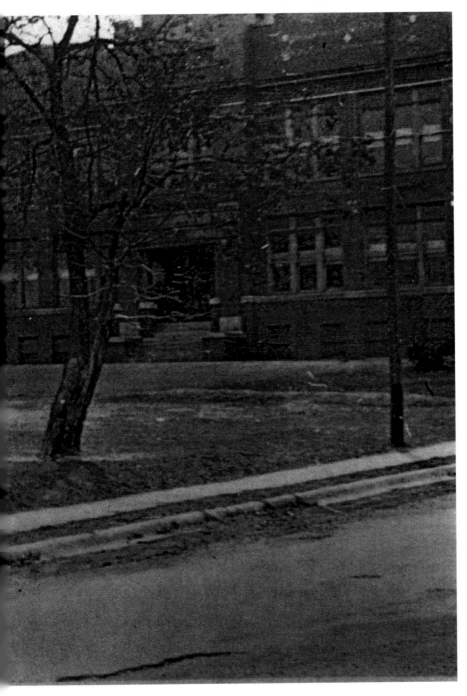

A smaller version of the flower that made Zionsville famous in the 1930s, this red dahlia grew in the garden of local artist Deenie Andrae, who preserved it on film. *Courtesy of the photographer.*

The copy read:

The gaiety of flowers, of birds and of beautiful lawns beckons the city dweller—away from the smoke and grime of a crowded town—to Zionsville where all the comforts and conveniences of a modern city combine with the pleasures of fresh air and open countryside to make delightful living.

Here the city worker can be close to his job—only 15 miles from Indianapolis, excellent bus service and paved road all the way—and yet close to the great out-of-doors in a community of friendly people. Educational facilities are of the best, and children rejoice in the means of a happy childhood. Modern homes are built from $4,000 to $6,000; rentals range from $20 to $30 per month. Come and see for yourself or write to Secretary of the Lions Club. Zionsville will extend a hearty welcome.

A dahlia photograph appeared at the bottom of the advertisement, next to the slogan: "Zionsville: The Dahlia City" and the directions: "25 minutes from the circle PAVED ROAD ALL THE WAY, 15 Miles Northwest of Indianapolis, ½ Mile West of State Road 29 [now known as both State Road 421 and Michigan Road]."

Lions Club Promotes Town, Supports Activities

LIONS USED FISH FRY AND DONKEY SOFTBALL TO SUPPORT PARK

Rarely do I copy articles from old newspapers when I do not find other news of note on the copied section of a page, and often that news makes a valuable contribution to my knowledge of local history.

For instance, in pursuing information on the photograph of four Lions Club members holding a softball trophy, I came across two articles, a year apart, that detailed fundraising projects the Lions Club used to support its new park. I already knew that fish frys had been successful fundraisers for several years at some point in Lions Club history, but I didn't know when those fish frys began, and I hadn't heard about the donkey softball game.

Sometime during my high school years, I remember attending a donkey basketball game, but using donkeys to play softball sounds like a much greater challenge. I was intrigued.

Here's what I learned, just as it was printed in the *Zionsville Times*, except for an added date. The announcement came on July 27, 1939, and the report on August 3, 1939.

> *The Lions expect to entertain a thousand people next Monday [July 31, 1939] evening when a game of soft ball will be played on donkeys, on the local diamond. The game will begin at eight o'clock. The admission is 10 and 25 cents. The money made on the game will be applied on the playground debt.*
>
> *Twelve donkeys will be used in the game. The pitcher and catcher will occupy their normal positions. When the batter hits the ball he must make first on a donkey. After a man fields a ball, he must mount a donkey before he can throw it to a baseman.*
>
> *The game is good for many laughs and local players will be adorned with many bruises the next morning.*

Editor Bernard Clayton was correct—the game did produce bruises the next day, but unfortunately, the injuries went beyond his prediction.

> *All of the members of the Lions Club think that the donkey ball game played Monday evening at the new park was a decided success, the club clearing $70 on the venture.*

Two men, however, have reasons to regret the game. Earl Smith is nursing a broken collar bone and Foster Wharry will be unable to write checks for months because of a badly sprained hand.

Both men were injured in the same manner. About half of the donkeys were docile and would carry a man without bucking. They were used by the team in the field. The rest bucked at the least provocation and they were used to carry the base runners. Every player was pitched at least once over the donkey's head and Earl Smith hit the ground several times. The last time he lit on his shoulder, breaking the collar bone. Wharry was injured in the same manner.

The contest did not prove very exciting. The donkeys could not be guided as they were held with a common halter. Few scores were made and the only fun the crowd had was caused when a man was pitched off a donkey. The attendance was estimated at around a thousand people.

Announcement of the Lions Club's big fundraiser the next year appeared in the *Times* of July 25:

In order to raise money to assist in paying for the equipment used at the playground, the Lions Club, at a dinner held Tuesday evening at the Methodist church, decided to stage a fish fry Tuesday evening, August 20th. A committee consisting of Bernard Clayton, Clyde Harris and Cap Shepard will have charge.

Thanks to the intact headline of the fish fry report, printed in the August 22, 1940 edition of the *Times*, we learn that the fundraiser netted $175 for the club. As was his habit, Editor Clayton clipped the first paragraph of the article at some later date, perhaps to use in a column twenty-five or fifty years later. Whatever his intent, the microfilm at the P.H. Sullivan Museum has numerous first paragraphs missing during Clayton's editorship.

The balance of the fish fry story read as follows: "More than 1500 people were present and all food on the ground was sold with the exception of sandwiches. The ball game between Whitestown and Zionsville resulted in a score of 9 to nothing in favor of the local lads."

ENTERTAINMENT CAME IN MANY FORMS

Susan B. Anthony's Local Address Was Well Received

When famed suffragist Susan B. Anthony was scheduled to appear in Zionsville at Clark's Hall, her speech was enthusiastically heralded by the local press. A full house was predicted for the event that was scheduled for February 3, 1877.

The report in the following edition of the *Zionsville Times* proved the editor's predictions to be accurate. (I have edited only to break the copy into paragraphs for easier reading.)

Under the headline "Woman Suffrage" and the subhead, "Miss Anthony's Lecture—Woman and the Sixteenth Amendment":

Last Saturday night a large audience assembled in Clark's Hall to hear the long expected lecture by Miss Susan B. Anthony. The people gathered at an early hour, remembering the old saying: "first come, first served," and everybody wanted the best seats in the house on an occasion like this.

After quite a long wait, Miss Anthony arrived and made her appearance on the stage. Two or three ladies took seats on the stage with her, and the lecture commenced. Every one was agreeably surprised at the full and pleasant voice of the lecturer, and the manner with which she delivered her eloquent plea for woman suffrage.

The lecture, as a matter of course, was an able one; the name of the lecturer insured that in advance. It was full of strong points in favor of the

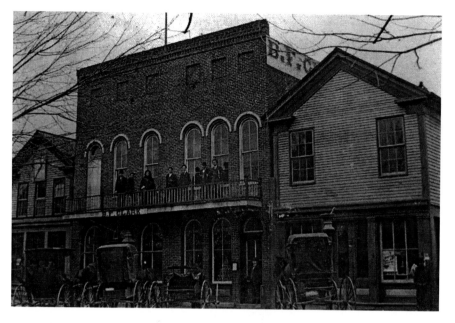

Clark's Opera Hall, on the second floor of the store occupied by B.F. Clark's store, was the venue for speeches by Susan B. Anthony, Elizabeth Cady Stanton and James Whitcomb Riley. *Courtesy of the Sullivan Museum.*

right of women to share in the government they help support. She announced the policy of the woman suffragists in demanding a Sixteenth Amendment to the constitution, and at the close of the lecture, read a petition for that purpose, which she requested published in the Times. *The following is the petition:*

"To the Senate and House of Representatives in Congress assembled:

"The undersigned citizens of the United States, residents of the State of Indiana, earnestly pray your honorable bodies to adopt measures for so amending the constitution as to prohibit the several states from disfranchising United States citizens on account of sex."

The petition will probably be circulated here, as a result of the lecture. At the close, Miss Anthony called for a vote of all the ladies present who desired to vote, and an apparently unanimous "aye" was the response. She then called for all the men present who were in favor of woman suffrage to vote "aye," and nearly every gentleman in the house responded.

Miss Anthony, as well as every one else, was surprised, and gratified at the unanimity of feeling on the subject. Taken all in all, our citizens have enjoyed a rare treat, which has been thoroughly appreciated by all who

were able to attend the lecture. It gives our town an enviable prominence to be visited by such a lecturer as Miss Anthony, and gives our citizens an opportunity to hear a really able address, not afforded outside of cities.

In this connection, we are glad to announce that probabilities point to another lecture from Mrs. Elizabeth Cady Stanton, a lady of equal prominence with Miss Anthony, before long. Mr. Clark, with his customary enterprise, is endeavoring to secure a lecture from Mrs. Stanton at some early date and we hope to be able to say next week that she will positively appear before a Zionsville audience.

And she did—two months later.

RED RIBBON TEMPERANCE MOVEMENT HIT ZIONSVILLE IN 1877

Along with the railroad and its benefits to the new community of Zionsville came an unforeseen problem. The men who laid the tracks, far away from home for months at a time, and faced with little to do once their day's work had ended, drew saloons, or "blind tigers," as they were sometimes called, ready and waiting to quench their thirst. Some of the local men who had been hired by the railroad took to joining their newfound friends for a drink, or two, or more. And soon it got out of hand.

The railroad crews moved on, but some of the saloons stayed. Bad habits formed were hard to break. When the Red Ribbon Temperance movement reached town, it was welcomed with open arms by many.

The rallying of men in a community, and beyond, to lend moral support to each other in an effort to better themselves as men did not originate in 1995 with the Promise Keepers or the Million Man March. Research could, undoubtedly, point to other rallies dating back to the early days of civilization.

For our purpose, let's travel back to 1877, when such a rally united the men of Zionsville. The first report came on the pages of the *Zionsville Times* of Saturday, August 25, 1877. My only editing was to break the copy into shorter paragraphs for easier reading.

Editor Pentecost reported:

The red ribbon temperance reform movement has at last reached Zionsville. It was inaugurated last Tuesday evening by J.C. Pearson of Indianapolis,

and meetings have been held every night since. One hundred and thirteen persons have signed the pledge and donned the ribbon, among whom are several who have been drinking men.

Meetings will be held to-night at the M.E. Church and tomorrow afternoon at the Christian Church, and tomorrow night probably at the M.E. Church. It is also proposed to hold meetings every evening next week.

This reform movement is one in which every citizen can and should co-operate. Everybody admits that temperance is a good thing, both for the individual and the community, while intemperance is equally bad for both, and the platform of the Red Ribbon Club is broad enough for persons of all beliefs and no belief at all to stand upon.

Every man and woman feels or ought to feel interested in his own good and the good of the community, and that is all that is sought by the "dare-to-do-right" movement, but it is an object great enough for all of us. Let's all turn out to the meetings.

Captain B.J. Johnson of Indianapolis, a reformed drunkard and saloon keeper, will be here over Sunday and conduct the meetings.

That the movement drew an immediate reaction locally is indicated from this brief paragraph in the personal column the next week: "The total receipts at Engesser's saloon last Tuesday were fifteen cents, and on Wednesday we understand they footed up the glorious sum of $0000. Lively business. So much for red ribbons."

That same issue, September 1, 1877, reports further on the group:

The red ribbon meetings this week have been largely attended and very successful. Two hundred and fourteen signers to the pledge have been obtained up to Friday morning, making total membership of 327. Quite a large proportion of these are drinking men who have resolved to reform, and we hope to see our citizens uphold and assist them in every way in keeping their pledges.

Ferd Engesser, popularly known as "Uncle," by the way, is helping the cause by promptly ordering out of his saloon everyone whom he suspects of being a red ribbon man. Our people have all taken hold of the work energetically, and it is progressing beyond the most sanguine expectations.

Captain Johnson of Indianapolis, who has been with us during the entire week, has proved a very able conductor of the movement, and his appeals to our young men, backed up by his extensive experience in the

whisky business, have been remarkably successful. It looks now as if in a short time one or both of the two saloons in town would be compelled to close for want of patronage.

A very good suggestion was made the other night by Captain Johnson, to the effect that the temperance people subscribe a sufficient sum of money to buy the stocks of liquor in the saloons and throw them away, thus enabling the proprietors to engage in other business. This would be the best way of closing out the saloons, and fully in accordance with the principles of the red ribbon movement, as it would entail no injury on the saloon keepers.

It is interesting to note that in the census of 1870, Zionsville had a population of 956, while in 1880 it had decreased to 855.

ZION PARK GETS BOOST FROM SALE OF STOCK

The first Camp Meeting, or Zion Park Assembly, as it was sometimes called, was held in 1891. So successful was the annual event, and the group picnics that brought many visiting Sunday school groups to town throughout the summer, that many more Zionsville residents decided to join those who were already shareholders. In late August, following the third successful assembly, fifty shares of new stock were purchased, enabling the park directors to purchase additional land, improve the grounds and add such attractions as a lake.

A month later, on September 29, 1894, the *Zionsville Times* reported,

The new ground for Zion Park has been secured and the work of making the lake is now under headway. Saturday the directors of Zion Park let the contract for building the levy, which will form the lake, to Frank Gregory for the sum of $560 and on Tuesday morning he began the work with as many teams and men as can be worked to advantage on the ground...The additional ground secured gives the park an area of nearly 20 acres and it is intended to cover five acres of this with water.

On October 13, the paper reported something that will come as no surprise to today's homeowners: "Work on the levy of Lake Como stopped Tuesday night until Monday of next week, owing to the contractor, Frank Gregory, having other business to look after."

Proof that the contractor did get back to building the levy came March 23, with word in the paper that

> *the first sailing craft of any kind was launched on Lake Como, Tuesday. Mark Harvey, George Doehleman and Bert Harrison took the first voyage and Mark desires us to say to our Northfield correspondent that the boat went right along on the top of the water just the same as it would on any stream or lake and requests that he come down as soon as convenient when, in company with the* Times *man, for his perfect safety, Mark will accompany him on a voyage of discovery around the lake.*

With such an attraction to be unveiled for summer picnickers, Editor Calton Gault urged, on April 6, 1895, "The street leading to Zion Park should be graveled and it should be done at once before the pic-nic season opens."

In the same edition of the newspaper, he noted, "After the break in the levy at Lake Como was fixed Monday, temporarily, the water was let out and the drain pipe raised five feet and a solid 8-inch iron pipe put in and the break thoroughly mended. While the water is out some other improvements will be made. A good rain is now needed to again fill the lake to high water mark."

Gault's wish for street improvements was not realized before the 1895 Camp Meeting.

In late August, he wrote, "There should be another big picnic of some kind at Zion Park after the street improvements are finished. During camp meeting and old settlers [meeting] the streets have been torn up and we should try some way to get the people here to see the work when finished."

Yet that fall, "A power pump at the school house well" was put in to supply water to the park. According to Gault, "The well will supply all that is needed and have some to spare."

The following June, the paper reported that Frank Gregory had put up a "wire coaster across Lake Como that is quite a novelty." Also, the Zionsville Band dedicated the new bandstand on Kerguland Island in Lake Como with a special program.

Improvements continued in August 1896. "The Park directors have decided to paint and handsomely decorate the auditorium. They will place 5 or 6 incandescent gas lights in different parts of the Park. These will greatly add to the appearance and convenience of the grounds."

Entertainment Came in Many Forms

In May 1897, large trees in the park were topped and trimmed and about seventy-five small trees were planted. Three new boats were also under construction by M.S. Anderson, and the old ones were repaired and painted.

When Camp Meeting opened in 1898, a new cottage had been erected as headquarters for the clergymen who were to speak during the assembly. Also, four acres adjoining the park, owned by the Liebhardt family, had been leased for use over the next four years. "This gives considerable additional room and will make a beautiful place for dinner parties as it is well shaded with natural forest trees," the *Times* reported on July 2.

The Reverend Mr. F.W. Hemenway, who had local connections, was to come from his home in Old Orchard, Missouri, as musical director during the assembly season.

VILLAGE PLAYHOUSE ORIGINATED OUT OF "HARM'S WAY"

When the Dick Way family moved to Zionsville from Eagletown in 1907, daughter Eva entered the fourth grade at Zionsville Grade School in the yellow brick building on Walnut Hill.

A girls' basketball team was started while Eva was in high school, but it was soon abandoned for the sake of modesty. It seems that the young ladies wore the traditional black bloomers and middy blouses of a gym class, but lacked the privacy of gym class for their after-school games. Eva recalls that some boys came into the gymnasium while a game was in progress and the horrified teacher stopped play and made the girls sit on the floor until the boys had left.

When the reception for her senior class, the class of 1919, was held in the K. of P. Lodge Hall on the second floor of the old town hall on Cedar Street, little did Eva dream that one day she would own the Zionsville Theatre on the ground level of the building...but that came fifteen years later.

In 1921, she married Clyde Harris, and the young couple moved to Chicago, where Clyde had a job as a projectionist for Fitzpatrick & McElroy Theaters in Blue Island, Illinois. During this time, Eva attended beauty school and opened a beauty shop in Chicago.

When the Harrises decided to return to Boone County in 1934, she opened Eva's Beauty Shop in their home, operating it there for a few months before

The former town hall over the years became a movie house, a skating rink, a dance venue and home to the Village Playhouse, not to mention a pizza parlor. *Courtesy of the Sullivan Museum.*

moving to the Main Street location later occupied by the Sow's Ear Antique Shop. Later that year, Clyde bought the town movie house, the Zionsville Theatre, from Neal and Shelbourne, who had shown their first movie there ten years earlier.

For about eighteen months after Clyde's death in 1944, Eva tried to operate both her beauty shop and the theatre. She recalls that her daughter, Louise (Ramsey), "came home from school in Chicago. I didn't drive a car, and she came home and helped me pick up my shows on 'film row' and helped me with the theatre."

Each of the major motion picture studios had screen rooms in Indianapolis in a span of about two blocks south of North Street on Illinois. Eva remembers,

> *We would go down and preview, then go to the Variety Club for lunch or to the corner drugstore. You would buy [lease] pictures by the block, usually by the year. There was a good show and two or three B pictures in each block. I had to run them all, but the larger theatres would run the*

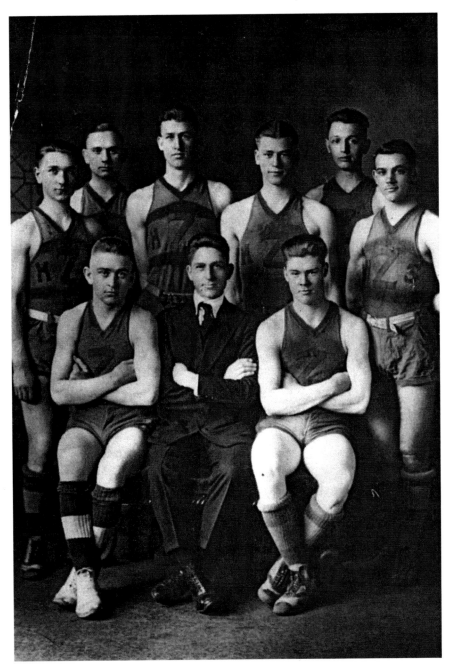

The boys' basketball team, circa 1918. *Courtesy of the Sullivan Museum.*

good pictures and send the B pictures to drive-ins. I ran the B pictures on Tuesdays and Wednesdays and the good pictures the rest of the week.

Admission to the movie was thirty-five cents and included, in addition to the feature, a newsreel, a cartoon and sometimes a short subject, like the Disney one-reel nature films. Popcorn was ten cents a bag.

On Saturday afternoons, matinees attracted the younger generation with the same feature that was shown at night, plus a serial. Roy Rogers movies were big drawing cards and turned a good profit for the theatre. "With Roy Rogers and Dale Evans, you'd always have a good crowd," Eva recalled. "That was a Republic picture and we paid a flat price for it. With the good Disney movies or epic films, you had to pay a percentage, sometimes up to 50 percent, and you'd have to pay your expenses out of your 50 percent."

The theatre, which staged its first play in 1903, was destined to smell of grease paint once again before its door finally closed in 1968.

Eva remarried in 1947, and she and her husband, Christopher Harm, remodeled the stage in 1964, put in new dressing rooms and lighting and renamed the theatre the Village Playhouse. Although they continued to show motion pictures, they produced two successful plays directed by Sol Blumenthal. The first, *Mornings at Seven*, boasted a local actress and actor in its cast—Marian Farrell and Paul Johnson. Drama critic Corbin Patrick gave it a good review.

The second stage production was *Light up the Sky*, by Moss Hart. Unfortunately, Mr. Blumenthal had surgery and left the theatre, and since no one his equal could be found, the plays were abandoned in favor of movies and an occasional vaudeville show.

Although there was no film rating bureau in those days, theatre owners themselves did their own rating. "I would run nothing a child couldn't see," Eva acknowledged, "and that was one reason I closed in 1968. They would say, 'Mrs. Harm, you don't run this type of picture in your theatre, and we just don't have anything for you anymore.'"

OFF MAIN STREET PLAYERS TAKE CENTER STAGE

"Sometime you should write about the Off Main Street Players" is a subtle request I have heard several times in the last few years. Each time it came when I was in the middle of a series or had committed to focus on a

Off Main Street Players found a home in an abandoned barn on property now part of Raintree Place. A lot of hard work by many people produced a number of well-accepted plays. This playbill is from one of them. *Courtesy of the Sullivan Museum.*

particular subject or subjects as soon as possible. Writing my recent series on the Maplelawn Farmstead, with its three barns, called to mind the subject I had neglected. The barns were the connection.

While Maplelawn barns were used for the purposes for which they were built, the Off Main Street Players adapted a no longer used barn as their venue. The meeting of the players and the barn was fortuitous for both.

In 1901, Dr. James O. Hurst, a local dentist, acquired a 120-acre parcel of land on both sides of Eagle Creek, east of town on what is now State Road 334. The heavily wooded portion east of the creek was known locally as Hurst Woods. A large sugar camp was held there each year. Earl Smock, whose father, Dave, rented the farm from 1930 to 1950, says 150 buckets used for catching the sap were left at the site of the camp when the Smocks arrived.

A traditional bank-style dairy barn was built on the property, circa 1925, with a hipped roof and an attached shed. The barn was large enough to house twenty head of dairy cows. The shed was used as a milking parlor. Earl says the walk-out basement where the cows were kept had frequently painted plaster walls and was kept at a steady seventy-degree temperature. Each cow had its own stanchion, water fountain and feed trough. The loft above stored hay and grain.

On the west side of the creek, in the area that now includes Lions Park, Smock grew corn, soybeans and alfalfa.

Dr. Hurst and his wife, Margaret, died within two weeks to the hour of each other in late 1926 and early 1927. The farm was inherited by their son, Everett, also a dentist, who lived in Eugene, Oregon. With the owner so far away, Hurst property, including the farm, was managed by Dr. Paul Ferguson, who had shared the dental practice with Hurst.

After the Smock family left the property, another farmer rented the land, but by 1968 the barn sat empty, in good condition but in need of some repairs. That's when the barn and the Off Main Street Players met.

Organized in the fall of 1965 in the home of Jane and Ernest "Bud" Pitts, the amateur thespians staged their first plays in the Zionsville High School. They knew that could be only a temporary site.

To put it simply, the barn and the Players needed each other. In 1968, they were connected by a one-dollar-a-year lease from then owners Verco Corporation and "sweat equity." One of the obvious early attributes of the group members was their willingness to do whatever it took to turn the barn into the very best theatre they could create.

Entertainment Came in Many Forms

Volunteers (with a little help from their craftsman friends) raised the floor, added a large stage, installed comfortable plush seats and added a loft for thirty additional seats. They also added an interior staircase to the loft from the lobby and a wrought-iron spiral exterior staircase as a fire escape. For its part, the barn contributed its hipped roof and wood construction, creating excellent acoustics and eliminating the need for an electrical sound system.

While the men were engaged in the heavy construction, the women were not idle. After the group purchased 140 fifty-year-old chairs formerly used in the Circle Theater in Indianapolis, the women, under the direction of Players President Jan Pitts, took off "tons" of chewing gum from the bottoms of the seats, using a combination of chisels, putty knives and screwdrivers.

Everyone knows you can't have a stage without a curtain—another costly accessory requiring more cash than was readily available. Ingenuity solved the problem. John Lippke suggested using a scrim, like those used in vaudeville days.

The end result: a twenty-foot-wide canvas drop, painted light green to complement the Williamsburg green of the theatre. It was divided into forty portions, each bearing a sponsoring business's name, trademark or other significant design. James Boots designed and painted the scrim while Bud Pitts and John Lippke constructed the pulleys and other practical features.

In front of the scrim hung a patchwork draw curtain made from fabric squares donated by the women and then artistically arranged on the floor of the Pitts' home before assembly and installation.

Visit us at
www.historypress.net